スマホで描く！
はじめてのデジ絵
ガイドブック

（萌）表現探求サークル／著

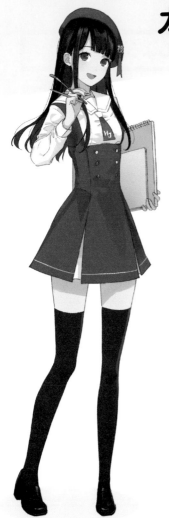

3章 デジ絵を描いてみよう！ 53

4章　デジ絵イラストメイキング　89

スマホで本格的なイラストを描くときの心構え ·································· 90

イラストメイキング① 透明感のある人物イラストを描く ·································· 94

私、夢色カクノが
ナビします！

ホビージャパン
技法書シリーズ
公式マスコットキャラクター

はじめに

デジタルイラストって、憧れますよね。

キラキラで、色鮮やかで、完成度も高く見える。
こんなイラスト、自分も描いてみたい……絵を描くのが好きな人なら、誰しも思うことでしょう。

でも、パソコンとペンタブレットを買うのは高くて手が出せないし、家族共有のパソコンは長時間使えない、何より家族に絵を描いているところを見られたくないという方もいると思います。
もしくは、お絵描きを始めてみたいけど、いきなり高価なツールを買うとなると、ハードルが高いので、まずは気軽にチャレンジしてみたい、という方もいるでしょう。

そういう方におすすめなのが、スマホで描くデジ絵です。
今は、スマホさえあれば、無料で高品質のお絵描きアプリがありますし、指だって立派なペンになるのです。

さらにスマホのお絵描きアプリなら、複雑な機能もできるだけ簡略化していますので、デジ絵初心者の方にもぴったりです。
慣れたら、パソコンお絵描き勢も顔負けの高クオリティイラストを描くことだってできるようになります。

さあ、スマホとこの本を片手に、さっそくデジ絵を描いてみましょう！

1章

デジ絵を描く
準備をしよう

イラストを描き始める前に、まずは準備を整え
ましょう。

準備といっても難しいものではありません。ス
マホのチェックだったり、お絵描きアプリを選
んだり、お絵描きのためのペンをそろえます。
それらのツールを選ぶための参考になる情報を
まとめたので、自分にあったアプリや、タッチ
ペンを選んでください。

インストールする前に

お絵描きアプリをインストールする前に、まずは自分が使っているスマホのチェックをしましょう。お絵描きアプリをインストールする容量があるか、OSは更新しているかなど、お絵描きをスイスイ進めるための準備をします。

スマホ本体のチェック

パソコン（PC）に液晶タブレットや板タブレットでお絵描きをするときもそうですが、使う端末（今回はスマートフォン）のスペック（性能）は大事です。

たとえば、スマホでゲームアプリを遊んでいるとき、スマホ本体が熱くなったり、アプリの動きが遅くなったり頻繁に落ちてしまったり、皆さんも経験ありますよね。それは、アプリの性能にスマホ本体の性能や処理が追いついていないから起きることです。お絵描きアプリも同じように、細かいイラストを描くためには、最低限古すぎない機種であることが大事です。

ほかにも、スマホの容量を確認しておきましょう。

【設定】→【一般】から、空きストレージを確認することができます。イラストを保存する容量も必要ですが、写真や動画などでスマホの容量を圧迫していると、スマホ自体の動きがどんどん鈍くなります。お絵描きソフトによっては、空き容量の指定がある場合もあります。

大体 5GB 〜 10GB ほど容量があると安心です。

容量が足りない場合は、ストレージの使用状況を見て、いらないアプリやメディアなどを消しておきます。

OS を最新バージョンに

OS とは、Operation System の略で、スマホを動かすための基本になるソフトウェアになります。

スマホを使用していると、数か月に1度くらい、「ソフトウェアのアップデート」が発生することがあるかと思いますが、この OS は日々スマホの機能をアップするために更新されており、機種にかかわらず、最新の OS にアップデートすることができます（ただし、あまりに古い機種の場合、スペックが足りなくてアップデートできない場合もあります）。

お絵描きアプリを使用する前に、最新の OS にアップデートしているか確認しておきましょう。【設定】→【一般】→【ソフトウェア】で確認することができます。

「OS は最新です」となっていたら問題ありません。自動アップデートを ON にしておけば、常に最新の OS になるときに通知が来て、アップデートしてくれます。

Check!

スマホが熱い！

熱くなりすぎると急にアプリが落ちることも！

タッチペンを選ぶ

スマホ本体の準備ができたら、次に、お絵描き用のタッチペンを選びましょう。スマホに対応したペンは、100円ショップや家電量販店、ネットショップで手に入れることができます。ここでは、主なタイプのペンを試して描いてみたので、紹介します。ペンはお絵描きにとって最も大事な要素でもあるので、自分に合ったペンを探してみてください。

1 ペン先が尖ってないゲーム用ペン

↑ゴムでできている

ペン感をあまり感じないペンです。描くというよりタッチするという目的のペン。

　100円ショップでも売られているコスパ抜群のタッチペン。
　先が丸みを帯びているタッチペンです。スマホの液晶を傷つけないように、先端部分は柔らかなゴム素材でつくられています。そのため、液晶にペン先をあてただけでは反応せず、しっかりと押して描かないといけません。つまり筆圧感知はかなり悪め。

　また、鉛筆で描くことに慣れたユーザーには、ペンとはかなりかけ離れた形状になっているので、慣れるまでに時間がかかりそうです。基本は、お絵描き用というよりも、ゲームなどに向いているペンだと言えます。

　右のイラストは、同じような形状のペンの中でもかなり細目のペン先4.5mmのペンで描いたものです。100円ショップで売られているものは、ペン先が太いのでさらに描きづらいでしょう。

力を入れないと感知しないので、ある程度力を入れ続ける必要アリ。

力を入れるとゴムがぐにゃっとつぶれる感じ

ぷにゃっ

ペン先はむにゅっとつぶれます。固くないです。

ざっくりとした線のイラストなら逆に描きやすいかも？

2 ペン先に丸い円盤がついているペン

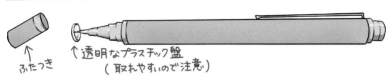

一見普通のペンに見えますが、ペン先に透明なプラスチックがついています。

　先端に透明な円盤がついているペンです。**1**のペンに比べたら、割と形状は普通のペンに近く、円盤がついている以外は普通のペンに見えます。こちらも100円ショップで手に入れることができます。

　この透明なプラスチックの円盤は、おそらく液晶画面を傷つけないために存在していると予想できますが、お絵描きのときには、かなり邪魔に感じます。この円盤のせいで、ペンを垂直に立てて描く必要があるので、実際にはペンの動きはとても見づらいと感じます。ただ、慣れたらちゃんと描けるようになりそうです。ペン先は、普通の鉛筆やペンに比べたらやや太く、細身のマーカーくらいの印象です。

　それ以外は、ペン自体も軽く、感知もかなり良いので、**1**のペンよりはおすすめします。

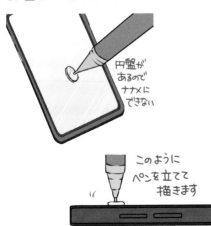

円盤があるため、ナナメに持つことができません。ペンを画面と垂直に立てて描かないといけません。

プラスチック盤の存在に慣れることができたらかなり描きやすいです。

11

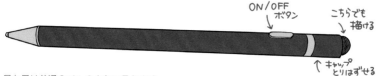

ON/OFFボタン

こちらでも描ける

← キャップ とりはずせる

見た目は普通のペンのように見えます。

　こちらのペンは 1000 円〜数千円します。ペン先は銅でできており、充電式になっていて ON にすると、その電磁力で液晶が反応します。

　ペン先はかなり細くて、今までのペンの中では一番、使い慣れたペンの感覚でしょう。ただし、紙に描くようなペンと同じだと期待してはいけません。さらに、液晶タブレットや Apple Pencil と同じような描き心地でもありません（これらのペンは、紙とは違う感覚ですが、液晶上になめらかな描き心地を得られます）。

　このペンも、基本的には斜めから線を描こうとしても感知しないため、できるだけペンを立てて使う必要があります。描き慣れたら細かいところまでしっかり描けるようになりそうです。ただし、それなりにお値段はしますし、家電量販店では売ってないこともあります。

　また、充電式なので、適度に充電を行う必要があります。これまでのふたつのペンに比べると重いですが、長時間描いていても疲れるほどではありません。

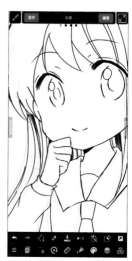

ペン自体は重いですが慣れたら細い線も描けます。

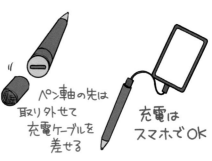

ペン軸の先は取り外せて充電ケーブルを差せる

充電はスマホでOK

充電はスマホでできます。1 時間充電すれば、数時間は保ちますので、そこまで気になりません。

4 指（人差し指）

そして最後はまさかの指！

タッチペンの場合、勢いのある直線や長い線を描く場合にはとても描きやすいと感じたのですが、反面、複雑な線や、塗りつぶしたり、線を重ねたりするときには、微妙に自分が描きたいところに線が描けないという悩みがありました。その場合に、指だと、細かい作業ができるなと感じました。ただし、鉛筆やペンから指に慣れるまでの違和感が強く、もともと指で絵を描くという習慣がないと最初は難しいでしょう。

その代わり、簡単なイラストから慣れていけば、最強のペンに化ける可能性を秘めています。ただし、長時間描き続けていると指の指紋がかなりすりきれます。

指で描く場合、長い爪は切らないといけません。

ペンできれいに引けない細かいところを描くことができます。

指で描くことのデメリット

指で描くことに慣れてしまうと、スマホでのお絵描きから発展して、パソコンでデジ絵を描こうとしたときに、その環境の変化に慣れるのが大変かもしれません。

指とペンでは、描いたときの感触も違いますし、画面への触れ方、筆圧なども変わってきます。指なら出せた細かい描写ができなくなることもあります。

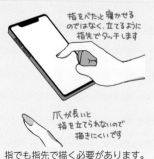

指をぺたっと寝かせるのではなく、立てるように指先でタッチします

爪が長いと指を立てられないので描きにくいです

指でも指先で描く必要があります。

総評……どのペンがおすすめか？

筆者が一番使いやすいと思ったペンは、まさかの**4**番、指でした！

普段は PC と液晶ペンタブレットでお絵描きしているので、指が使いやすいというのはとても意外な結果でした。

直線などの長い一本の線はペンタイプのほうが描きやすいと感じたのですが、細部を描くときに、ペンだとどうしても痒いところに手が届かない……と感じることがありました。そういうときに指は重宝しました。

最初は指で描くことに慣れませんでしたが、自分が描きたい線をそのまま直接スマホに描けるのが一番の要因でした。（ただし、指が汗ばんでいるといい線が描けないです……！）お絵描きを指でするのは確かに慣れていないのですが、それ以外の、たとえばフリック入力など、スマホを触るときには基本はペンではなくて指なので、いろんな機能やボタンを押したりすることに関して、指だと自然にできるなと感じました。

2 番目が**2**のペンでした！

ペン先についている透明の円盤があるのは最初かなり気になるのですが、ペン自身の軽さ、コスパの良さで一番でした。垂直にペンを立てないと液晶が反応しないのですが、透明の円盤があるおかげで、自然とペンを立てようという意識がつきます。

3のペンは、描き味自体は**2**のペンと似ています。また、普通のペンと同じ形状なので、描くハードルが低く感じました。ただ、コストがかかることを考えると、**2**のペンに軍配が上がったというところです。

1のペンは、残念ながらお絵描きには向いていないと感じました。2 回に 1 回は描けず、力を入れ続けるのが結構大変でした。

種類	コスパ	使いやすさ	描きやすさ
1のペン	3	1	1
2のペン	3	3	3
3のペン	1	3	2
4指	4	2	4

 スマホでお絵描きをするときは指がペンになる！

指で描くときの最大のメリット

　タッチペンよりも指で描くほうが描きやすいと感じた一番の違いは、スマホならではの理由でした。

　というのも、スマホでお絵描きをする場合、特に本格的に描くときには、限りあるスマホの画面でできるだけ細かくイラストを描いていかねばならないので、できるだけキャンバスを拡大して描いていくことになります。

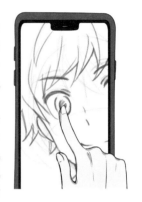

　ただし、ずっと拡大して描いていると、自分が今どこを描いているのか、ちゃんと描けているのかなど、確認しないといけないので、適宜縮小して全体を確認、また拡大して描く、縮小して確認、この動作をくり返すことになります。ペンで描いている場合、ペンをいったん置いて拡大するか、ペンで拡大機能のボタンを押すか、もしくはペンを持っていない指で拡大縮小をすることになります。

　これが指の場合、利き手の人差し指で描いて、拡大したくなったらそのまま中指を添えるだけで拡大縮小ができます。もともとスマホに慣れている私たちは、スマホで画像や地図などの拡大縮小に慣れているはずです、そのため、ペンで操作よりも、指で操作するほうが簡単なのです。

　つまり、指で描いていれば、拡大縮小もかなり時短できますし、自分の思うような大きさに拡大できたり、角度を変えることができます。

　指で描くのは難しいと思っている方は、ぜひこの拡大縮小の機能もセットで試してみてください。

お絵描きアプリを選ぶ

ペンを用意できたら、次に、お絵描き用のアプリケーションを選んでインストールしましょう。ここでは、初心者に向いているいくつかのお絵描きアプリを紹介します。ただし、最初からこれと決めるよりも、いろいろ試して自分に合ったアプリを選ぶほうがいいと思います。

アイビスペイント　ibisPaint

アイビスペイントは、株式会社アイビスが提供する無料で使えるお絵描きアプリで、シリーズ累計 1 億 5 千万ダウンロード（公式サイトより）という、大人気のアプリになります。

使ってみた感想ですが、まずシンプルでわかりやすいユーザインターフェースで、「とりあえず描いてみよう」という気持ちになりました。ツールバーの配置などは、慣れていけば問題なさそうです。

何よりアイビスペイントの最大の魅力は、ブラシや素材の多さでしょう。無料版の場合、すべてのツールを使おうとするとロックがかかっているのですが、短い広告動画を見ることで、それが解放されます。18 時間後にまた動画を見る必要がありますが、ストレスを感じるほどではありません。基本的には無料版で十分満足できます。

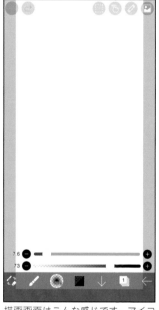

描画画面はこんな感じです。アイコンは一見何を表しているかわからないのもあるので、使いながら覚えていきます。

16

ただ、あまりにも広告が気になる方は、有料版を購入することで、ブラシは最初から使い放題かつ、広告も非表示にすることができます。有料版も税込み1100円（2021年10月現在）ですので、以降ストレスフリーで楽しめるという意味ではそこまで高いという額ではないと思います。

　素材も簡単に使えるので、いろいろ試しながら使ってみると、簡単に理解できると思います。逆に、多すぎて何を使っていいかわからないという人もいるかもしれません。

対応端末

・iOS版：iOS 11.0以降のiPhone（iPhone 5s以降）、iPad Pro、iPad（iPad 5以降）、iPad mini（iPad mini 2以降）、iPod touch（第6世代以降）
・Android版：Android 4.1以降のスマートフォン、タブレット

ブラシツールは、最初はロックがかかっていますが、広告動画を見れば解放されるので問題ありません。

テクスチャなどの素材も豊富に使えるのが魅力です。

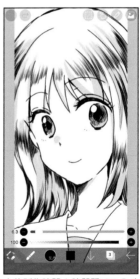

大体制作時間1時間弱でこのくらいです。慣れたら細かいところもしっかり描けると感じました。

クリップスタジオペイント　CLIP STUDIO PAINT

　PC やタブレットでは定番のお絵描きアプリで、株式会社セルシスが提供するクリップスタジオペイントのスマホバージョンになります。無料の場合は一日 1 時間しか使えないので、基本的には有料版を登録する必要があります。有料版にもいろいろコースがありますが、スマホだけで使う場合は、月額 100 円の pro コースで十分楽しめます。

　クリップスタジオペイントの最大の魅力は、ほかの PC やタブレット版のクリップスタジオペイントとのデータの共有ができることでしょう。スマホでしかお絵描きしない人はあまりメリットに感じないかもしれませんが、スマホで描いた絵を PC で開いたり、逆に PC で描いたデータをスマホで開いて続きを描くということができますので、普段は PC でお絵描きをしている人が、ちょっと外出先で描きたい、という場合にはとても便利です。

　ユーザインターフェースも、クリップスタジオペイントを使い慣れている人からすれば馴染みのある使いやすさ。さらに個人的には、描いたときの反応の遅延が少ないように感じました。

　ブラシや素材については、最初は少ないのですが、クリップスタジオペイントの公式サイトから好きな素材をダウンロードできるようになっています。ただ、このシステムに慣れない人は、最初は少し戸惑うかもしれません。

対応端末
[for iPhone]
・iOS 版：14.0 以降
　　・2GB 以上のメモリ必須　4GB 以上推奨
　　・5.5 インチ以上のディスプレイサイズを推奨
[for Android]
・Android 版：9 以降
　　・3GB 以上のメモリ必須　6GB 以上推奨
　　・6 インチ以上のディスプレイサイズを推奨

メディバンペイント　MediBang Paint

　全世界で 4000 万回以上ダウンロードされているイラスト／マンガ制作用アプリのスマホバージョンです。株式会社メディバンの提供となります。トーンの種類やブラシの種類も豊富で、PC 版やタブレット版とのデータ共有もできるようになっています。

　使ってみた感想ですが、まずソフトを立ち上げたときに見ることができるチュートリアル画面が丁寧で、初心者に優しいと感じました。いろいろな機能も紹介されているので、気軽に使ってみたくなる感じです。

　また、ユーザインターフェースの使いやすさはもちろんですが、特に良いなと思ったのは、ツールのところにちゃんと何のマークか書かれているところです。このマーク、慣れるまで何の機能のアイコンなのかわからないことが結構あり、とりあえず押してみて、なるほどこういう機能ね、と確認したりするのですが、メディバンペイントではちゃんと書かれています。そういうところも、より初心者に向けたアプリだと感じました。

　ブラシの色を変えるとき、左にある複数のバーを切り替える必要があるのがやや難しいかなと感じたくらいで、それ以外はとても使いやすいアプリだと思います。

対応端末
・iOS 版：11 以降（推奨端末　iPhone7 以降）
・Android 版：5.0 以降

プロクリエイト ポケット　Procreate Pocket

　iPadでも人気のお絵描きアプリ「Procreate」のスマホ版です。Savage Interactive Pty Ltd.で開発されました。

　まず、610円（2021年10月現在）の買い切り価格なので、最初に無料で使ってみて良さそうだったら買ってみるということができないため、ややハードルは高いかなと感じています。また、Android版がリリースされていないので、iPhoneユーザー向けのアプリとなっています。

　使ってみた感想ですが、かなり本格的にイラストを描くためのアプリという感じです。ブラシ素材が豊富で、ほかのアプリではあまり見かけない変わったブラシがたくさんありました。ただ、ペン入れをするためのペンツールよりは、筆やテクスチャなどのツールが豊富な印象です。描き味はとてもなめらかでよかったです。

　描画画面はあっさりしていて、お絵描きをするためのシンプルな機能は備わっています。ただ、機能はいろいろ限られているので、加工したり、マンガを描いたりなどにはあまり向いていないと思います。

対応端末
・iOS版：13.2以降

ツールなども基本的には隠れていて、キャンバスができる限り大きく使えるようになっています。ブラシは思わずいろいろと使ってみたくなるようなユニークなものが多くあります。

SketchBook

　簡単なスケッチから本格的なイラストまで描ける本格的なイラストアプリです。ユーザインターフェースはシンプルですが、使いたい機能はひと通りそろっています。

　開発はオートデスク社ですが、2021年6月にサポートを終了しており、現在の運営・サポートはSketchBook社が行っています。

対応端末
・iOS版：11.0以降
・Android版：5.0以降

ブラシツールを選ぶときの画面では、ブラシの絵が描かれているので、どういう形状のブラシなのかが見てすぐわかります。

Adobe Fresco

　画像や動画のソフトとして定番のAdobe社のお絵描きアプリケーションです。ただし、iPadとiPhone版はありますが、Android版は現在リリースされていません。また、最初にAdobeやGoogleIDなどでログインする必要があります（それらに登録していない場合は新規登録します）。

　一番の魅力は、Photoshopに搭載されている豊富なブラシツールを使える点です。

対応端末
・iOS版：13.0以降

総評……どのアプリを選べばいいのか?

いろいろお絵描きアプリを使ってみましたが、最初にご紹介したアイビスペイント、クリップスタジオペイント、メディバンペイントの3つの中でしたら、正直どれを選んでもお絵描きが十分楽しめると思います。

ペンの描き味、機能の豊富さ、初心者への分かりやすさなど、この3つはほとんど同じように感じられましたので、あとはインストールしてみて、自分で触って、なじみやすいアプリを使っていくようにするのがいいでしょう。

どれも無料で使えますので(クリップスタジオペイントも一日1時間は無料です)最初からこれと決めずに、一度使ってみることをおすすめします。

たとえば筆者は、ブラシのサイズや色などは、アイビスペイントよりもクリップスタジオペイントのツール配置のほうが使いやすいと感じました。ただ、素材の使いやすさについては、クリップスタジオペイントよりはアイビスペイントに軍配が上がりました。

この3つのアプリは、大差なかったので、あとは好みで選んでも大丈夫!

┌─ **Point!** ─────────

自分に合うアプリを使うのが一番!

クリップスタジオペイントの配置が個人的に使いやすかったのですが、これも好みの範疇かと思います。自分にあったアプリを選びましょう。

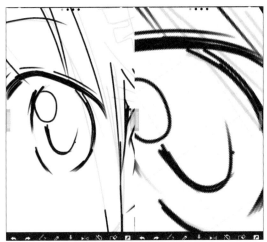

また、メディバンペイントのツール表記はわかりやすくていいなと思いました。

このように、使ってみないと自分に合う合わないはわかりませんので、まずはインストールして使ってみましょう。

もうひとつ選ぶ基準としては、今後 PC やタブレットでお絵描きをするかどうか、ということもあります。もし、いずれ PC でお絵描きをしたいという人でしたら、PC でも使えるクリップスタジオペイントかメディバンペイントを使っておくと、実際 PC を買ったときに、ツールアイコンなどが同じですので迷うことがありません。タブレットは、3 つのアプリならどれも対応しているので、特に考慮する必要はないでしょう。

プロクリエイトは初心者より、少し本格的にイラストを描きたいという人に向いているかなという印象です。また、マンガアニメ系のイラストよりも、ファインアートなどを描きたい人が使うような感じを受けました。

メディバンペイントは、拡大していくと、途中から自動的にグリッド表示に切り替わります。これは結構便利だと感じました。

そのほか用意するもの

　基本的にはスマホとタッチペンがあればお絵描きはできますが、あると便利なグッズを紹介します。

●フィルム

　スマホ用の透明のフィルムを貼っておきましょう。指で描く場合はモニターが指紋でベタベタになってしまいますし、ペンで描く場合、液晶のガラスが傷つく可能性があります。

●手袋

　タブレットもそうですが、指が触れるだけで液晶が反応してしまって、全然関係ないところに線を引いてしまったり、思わぬアイコンを押してしまったりすることがあります。そういう場合は、手が感知しないように手袋をつけ、描く指だけ切っておく、というふうにして使います。

●スマホケース

　スマホでお絵描きする場合、基本的には机に置いて描くことになるので、ケースがあるほうがスマホのすべり止めになります。革製の手帳型ケースなどは、スマホをしっかり固定できるのでおすすめです。

2章

デジ絵の
しくみを知ろう

この章では、デジ絵の基礎知識について解説していきます。

そんなことはいいから早く描き方を教えてほしい……と思うかもしれませんが、デジ絵のことを何も知らない状態で始めてしまうと、失敗することもありますし、何より、デジ絵のしくみは、今後お絵描きを続けていくうえで必ず役に立つ知識となるでしょう。

パソコンでお絵描きするときにも通用する共通の知識となります。

キャンバスサイズとpixel

デジ絵には、特有の専門用語がいろいろ出てきます。最初は聞きなれない言葉ばかりで把握するのも大変かもしれませんが、使っているうちに自然と覚えられるはずです。スマホでお絵描きする以外にもデジ絵での共通の知識になります。

キャンバス＝画用紙

キャンバスという言葉を聞いたことがありますか？

これはデジタルだけの言葉でもなんでもなくて、絵画を描くときのパネルに張られた布のことを指します。

この布にあたる、絵を描く土台のことを、デジ絵でもキャンバスと呼びます。

キャンバスにもいろいろサイズがあるように、もちろんデジ絵も大きさを変えて描くことができます。ただし違うのは、スマホやPCのモニターは常にサイズが一定だということです。つまり、画面上に見える大きさは同じだとしても、画面上では実際のサイズを縮小して表示されていたりするので、100%で表示したときの大きさが、本来のデジ絵のキャンバスの大きさとなります。

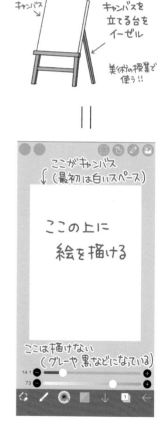

ここがキャンバス
（最初は白いスペース）

ここの上に
絵を描ける

ここは描けない
（グレーや黒などになっている）

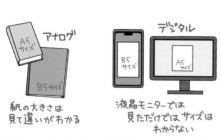

アナログ
A5サイズ
B5サイズ
紙の大きさは見て違いがわかる

デジタル
B5サイズ
A5サイズ
液晶モニターでは見ただけではサイズはわからない

デジ絵の場合、キャンバスの大きいイラストほど細かいところまで描くことができます。

大きさを「100%」に表示すると

こちらの2つのイラスト、一見同じサイズに見えますが……。

Bは33%の大きさで縮小表示されたものでした。実際のサイズはこう！

デジ絵はピクセルでできている

　右のイラストは、小さな正方形のマスを集めて作られたものになります。昔のゲームソフトのキャラクターは、このように作られていたりしました。

　しかし、今私たちがテレビやPCで見ている映像も、実は細かい正方形の集まりでできています。昔はカクカクしている絵になっていましたが、実際の作りは現在も同じです。

　絵を描くときにキャンバスサイズを選択しますが、そのサイズこそ、正方形の数になります。

　たとえば、1280×720、の場合は、幅が1280個の正方形の集まり、高さが720個の正方形の集まり、という意味です。この正方形の単位が、pixel（ピクセル、pxと書く場合もあります）と言います。キャンバスのpixelの数が大きければ大きいほど、正方形は細かくなるので、なめらかな線が描けたように見えます。その代わり、pixelの数が大きいほど、データのサイズも大きくなります。

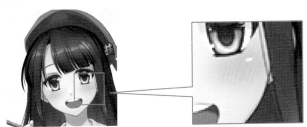

一見なめらかに見えるイラストですが、限界まで拡大すると、実際はpixelの集合体であることがわかります。

解像度

解像度とは、画像の密度を表します。印刷の際の点の数が、同じ面積の中で大きければ解像度が高い、点が少なければ解像度が低い、となります。

解像度が変わると画質が変わる

解像度は dpi という数値で表現され、これは「ドット・パー・インチ」の略になります。1 インチの中にどのくらい点（ドット）があるか？　ということですね。

解像度は高い方が細かい表現を表すことができます。同じサイズのなかに、みっしりと点が詰まっているのと、すかすかであるかの違いになります。

ぱっと見はわからないかもしれないですが、拡大してみるとその違いがわかります。

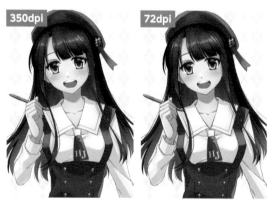

引きの画像だと一見、どちらも同じように見えます。

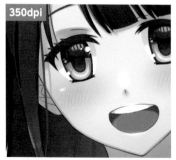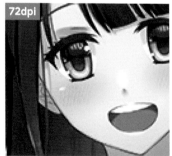

同じ箇所を切り取ったときに、解像度が低いとぼんやりして見えます。

媒体によって必要な解像度は異なる

解像度が高い方がきれいに見えるのであれば、解像度は高ければ高いほどいいと思われるかもしれませんが、そうとも限りません。つまり、点の数が多いということは、データが重たくなって扱いにくくなる……ということでもあります。

キャンバスサイズの大きさはそのままデータサイズの大きさにもつながります。

WEB上には、大量の画像データや動画データがあふれており、PCで閲覧する場合には問題ないことも多いですが、スマホで見る場合、大きなサイズの画像を表示する場合、時間もかかりますし、通信量も負担になっていきます。ですので、WEB上にアップする場合には、適切な解像度・サイズを選ぶのが良いでしょう。

解像度の表

印刷用	1200dpi	モノクロマンガデータなど
	600dpi	グレー（白黒とグレーのアミ）で描かれたマンガデータなど
	300〜350dpi	カラー印刷用のイラストデータ、マンガデータなど
Web用	72〜300dpi	WEB投稿・閲覧に適した解像度

雑誌や本などに掲載されているイラストは、細かいところまできれいに印刷されるように、高い解像度に設定して描かれています。スマホの大きさでそこまでの大きなイラストを描くのは、現実的ではありません。大きなイラストは、データが大きくなってしまうので、描くときの負担も大きいのです。

また、印刷用のイラストは、基本的にカラーイラストの場合、解像度300dpi以上で描かれています。ですが、600dpiにしたらもっと高画質になるかというとそういうわけではなく、350dpi以上の解像度にしても、画質はあまり変わりません。

Point！

WEB用のイラストは、72〜300dpiで、印刷用のイラストは300〜350dpiに設定して描こう！

第2章

29

よく使うサイズを知っておこう

　スマホでお絵描きする場合は、アプリの初期設定が大体72dpi以上にセットされています。72という数字は、webで閲覧するのにギリギリまで解像度を落とした数値で、ネット上の多くの画像もこの72dpiに設定されています。それ以下の場合は、かなり画像が荒く見えてしまいますし、それ以上だとデータが重くなってしまいます。

　PCやスマホで表示させたい場合に便利な画像サイズを覚えておくといいでしょう。待ち受け画像を作るときなどには、そのサイズで作ると全体をきちんと表示できます。

▶ デスクトップモニター・YouTubeの画面など
・2560 × 1440（pixel）
・1920 × 1080（pixel）
・1280 × 720（pixel）

　縦横比はどれも同じですが、高画質や、モニターサイズが大きい場合は大きめに。そうでない場合は、数値を下げても問題ありません。

▶ スマホの画面
・iphone X（5.8インチ）…1125 × 2436（pixel）
・iphone XR、iphone11（6.1インチ）
　　　　　　　　　…828 × 1792（pixel）
・iphone12,12Pro、13,13Pro（6.1インチ）
　　　　　　　　　…1170 × 2532（pixel）

待ち受け画像を作るときなどに参考にしてください。

▶ LINE スタンプ

・320 × 370 (pixel)

今では個人でも簡単に LINE スタンプを作ることができますが、公式からサイズの指定があり、このサイズより大きなサイズは登録できないようになっています。

▶ Twitter のヘッダー

・1500 × 500 (pixel)

横に長い画像になります。アイコンもそうですが、違うサイズでも、Twitter 上で多少の拡大縮小、位置ずらし、表示位置指定などの調整はできます。

ホビージャパン技法書アカウントのヘッダーです。

大事なのは縦横比

それぞれの画面に合わせた縦横比ではない場合、勝手に適応サイズにリサイズされることがあります。その場合、イラストが縦長になったり横長になったりと、画像が変に見えてしまいます。そうならないためにも、使いたい用途に合わせた縦横比にしておきましょう。縦横比が合っていれば、たとえばサイズが小さくなったりしていても、変に見えることはありません。

上の画像は縦横比が正しいイラスト、下の画像は縦横比が合わない例です。人物が横長になっています。

31

保存形式

画像データには、いろいろな保存形式があり、用途によって使い分けたりします。とくに、パソコンを使っていると大事な知識になります。

拡張子とは

　画像ファイルだけでなく、音楽ファイル、動画ファイルなど、すべてのデータ上のファイルには、それぞれデータの種類を表すための拡張子というものがあります。

　拡張子とは、ファイル名の後につけられている「.(ドット)〜」の英文字になります。たとえば、テキストデータなら、.txt、Word 文書なら .doc、音楽ファイルなら .mp3、動画ファイルなら .mp4 などです。

　この拡張子に対応したアプリケーションがあると、そのファイルを読み込むことができます。スマホだとぱっと見表示されていないのでわかりにくいかもしれませんが、音楽ファイルや画像ファイル、アプリのファイル、すべてに拡張子はついているのです。

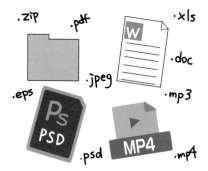

画像データにも拡張子はいろいろ

　画像ファイルにももちろん拡張子はついています。拡張子によって、画像ファイルの種類も異なります。普段は意識しないと思いますが、自分が描いた絵を保存するときに、どの拡張子になるのか、また、例えば画像を投稿するときにどの拡張子が対応しているのかなど、形式をそろえておくことが必要です。

画像保存形式の種類

PSD （拡張子：psd）	Adobe 社の Photoshop というグラフィックソフトの保存形式になります。印刷用の保存形式としては最も一般的で、多くのグラフィックソフトで PSD 形式の保存が可能となっています。レイヤーなどが統合されていなくても、そのままの状態で保存できますが、データサイズは大きくなります。	
JPEG （拡張子：jpg）	特に WEB 用で使われる保存形式です。レイヤー状態を保存できないため、1枚の統合された画像として保存されます。	
PNG （拡張子：png）	WEB 用で使われる保存形式です。レイヤー状態を保存できないため、1枚の統合された画像として保存されるのは JPEG と同じです。JPEG よりは画像をきれいなまま保存することができますが、その分データサイズは大きくなります。	

スマホのお絵描きならココ！

※レイヤーについては 36p 参照。

PNG と JPEG の違い

　PNG と JPEG との大きな違いとして、PNG は透過状態を保ったまま保存することができる……という点があります。簡単に言うと、絵に透明な部分を作れるということです。

　LINE スタンプなどは PNG でのデータを受けつけています。

　Twitter などでたまに見かける、同じ画像をクリックしたら隠れていた画面が浮き出た……みたいな仕掛けは、この透過状態を使ったものです。

　背景を透過したイラストを作りたいなら、PNG で保存するのがいいでしょう。

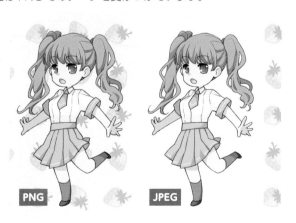

PNG　　JPEG

データの重さ

データの大きさ、重さ、データサイズなど……これらはすべて同じような意味を
もっていて、そのファイルやデータがどのくらいの容量なのかを表しています。

データのサイズ表記は Byte

イラストデータだけでな
く、音楽データや、アプリ
ケーションのデータなど、
コンピュータ上のデータの
容量はすべて Byte（バイ
ト）という単位で表現され
ています。

1 バイトはどのくらいの
重さかというと、半角英数
文字 1 文字のデータ量に
なります。

1024 バ イ ト が 1KB、
1024KB が 1MB です（た
だし、近年は微妙な端数を
省略して、1000 バイトが
1KB、1000KB が 1MB と
いうふうに数えることも多
いです）。

1 バイト	半角英数文字 1 文字のデータ量。主に テキストデータなどに使われます。
1KB （キロバイト）	1024 バイト。長めのテキストデータ や、小さめの画像データは、数百 KB 程 度です。 WEB にアップする画像も、できればそ のくらいに収めておくと見やすいです。
1MB （メガバイト）	1024KB。写真データや大きめの画像 データなどは数 MB 程度です。ほかに も、音楽データは 3〜20MB くらいの ものが多いです。限られたスマホの容 量を圧迫し始める大きさでもあります。
1GB （ギガバイト）	1024MB。動画データや、スマホゲー ムアプリなどは数 GB の容量であった りします。スマホではなかなか処理で きない大きなデータになります。
1TB （テラバイト）	1024GB。iPhone 13 Pro にて 1TB の 容量をもつスマホが発売されましたが、 基本的にはここからは PC の領域です。 PC のハードディスクは 1TB〜2TB の ものも増えてきました。

イラストデータの平均

イラストデータの重さは、基本的に KB や MB で表現されます。データが軽
いほうが、通信に時間もかからないので、無駄に重いデータサイズにならない
ように気をつけます。100KB くらいから、大きくても 2MB くらいにすると、
SNS にアップしても、ストレスなく表示されるでしょう。

画像データの重さ

基本的に、文字データよりも画像データのほうがサイズは大きく、画像も写真のようにより細かいもののほうがデータは大きくなります。同様に、イラストも、色数が少なく、単純なイラストよりは、緻密に描き込まれて、色も複雑なイラストのほうが、データは大きくなります。

大きめに作って縮小する

それならば、お絵描きをするとき、大きなサイズにならないように気をつけよう、と思うかもしれませんが、最初から小さなサイズで描くよりは、まずは大きなキャンバスで描くことをおすすめします。画像はあとから解像度を下げたり、サイズを縮小したりして、データを軽くすることができるからです。

ただし、元々小さなデータを拡大したり、大きな画像→縮小→再拡大、と元に戻しても、画質は元に戻らないので注意が必要です。

上の画像は 1500 × 1500pixel のイラスト、下の画像は 300 × 300pixel の絵を引き伸ばした画像です。後者の画像のほうがぼんやりとした絵になってしまいました。

レイヤー

紙とデジ絵の違いとして一番わかりやすいのは「レイヤー」があるかないかです。レイヤーを使いこなすことによって、デジ絵の完成度がぐっと変わってきます。

レイヤーは厚みのない透明フィルム

レイヤーとは、厚みのない透明なフィルムのイメージを持ってください。デジ絵は、何枚ものフィルムが合わさってできた状態なのです（よくアニメのセル画のイメージと表現されます）。

アナログの場合、1枚の画用紙やキャンバスに何度も何度も塗りをくり返すのに対して、デジ絵はレイヤーを分けることで、人物やパーツごとにイラストを分けたり、塗りを自由に重ねたりすることができます。レイヤーを使いこなすことが、デジ絵の上達への近道といっても過言ではありません。

このイラストは こんなふうに
分かれていて

アプリ上だとこのように
表示されています。

たとえばこのイラストは、「1：背景」「2：肌・瞳」「3：髪」「4：服・装飾」「5：線画」という5枚のレイヤーに分かれています。この5枚のレイヤーが合わさって、1枚のイラストになっています。レイヤーはそれぞれ透明なので、描かれていない部分は下のレイヤーに描かれた絵が見えるようになっています。

レイヤー表示については、基本的に上にあるレイヤーが優先されて表示されるようになっています。たとえば、真っ赤に塗りつぶされたレイヤーがあり、その上に真っ青に塗りつぶされたレイヤーがあるとしたら、実際に表示されているのは真っ青なキャンバスになります。これを利用して、ラフから仕上げまで、1枚のイラストデータで完結させることができます。

また、レイヤーは表示させる、させないを自由に選ぶことができますので、上のレイヤーが表示されない状態の場合、その下のレイヤーが優先して表示される、というふうになっています。

市松模様は透明を表す

レイヤーを追加すると、基本は透明状態のフィルムが増えると思ってください。

背景が白い場合は、「一面が白い色で塗りつぶされている状態」と認識しましょう。

白とグレーで表現された市松模様は、その部分が透明であることを表しています。

この状態は
レイヤーに
「白いインクで塗りつぶした
レイヤー」が含まれて
います。

実際のレイヤーは
「透明です」
透明を表現して
いるのが
この状態

レイヤーの種類

レイヤーには、通常の透過しないフィルムだけでなく、いろいろな効果をもたせることができます。下のレイヤーに対して、どのような合成の仕方をするか、モードによって使い分けることができるため、絵の全体的な印象や調整をするときに便利です。

どういう種類のレイヤーにするか

レイヤーのモードは、いつでも切り替えることができます。多くの種類があるので、すべてを使いこなすのは、最初は難しいでしょう。「暗く」「明るく」などレイヤーの種類分けが書かれているソフトもあります。

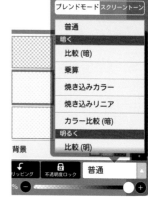

イラストの上に、ピンク色のレイヤーを重ねてみます。通常レイヤーだと下のレイヤーは見えなくなります。レイヤーモードを切り替えると、まったく違った印象のイラストになります。
ここでは、代表的なモードを紹介します。

▶ 暗くする効果

普通

通常のレイヤーモード。下のレイヤー
に対して透過されず、合成されません。

比較（暗）

下にあるレイヤーと、選択中のレイヤー
の色を比較して、暗い色が優先して合
成されます。

乗算

下にあるレイヤーと、選択中のレイヤー
の色を掛け合わせた合成になります。
カゲを塗るときなどによく使うモード
でもあります。

**焼き込み
カラー**

下のレイヤーの画像を暗くし、コント
ラストを強めたあとに、選択中のレイ
ヤーの色を合成します。

**焼き込み
リニア**

下のレイヤーを暗くして、選択中のレ
イヤーの色を合成します。

**カラー
比較（暗）**

比較と似ていますが、下のレイヤーと選択
中のレイヤーの色を比較して、RGB数値
（52p参照）の低いほうが優先されます。

▶ **明るくする効果**

比較(明)

下にあるレイヤーの色と、選択中の
レイヤーの色を比較し、明るいほう
の色が適用されて合成されます。

スクリーン

下にあるレイヤーの色を反転し、選択
中のレイヤーの色を掛け合わせて合成
します。乗算とは反対の効果になりま
す。

**覆い焼き
カラー**

下のレイヤーの画像の色を明るくし
て、コントラストを弱めるモードで
す。

**覆い焼き
リニア**

覆い焼きカラーよりも強い明るさにな
ります。

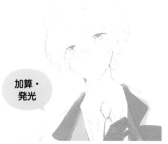

**加算・
発光**

下にあるレイヤーの色と、選択中の
レイヤーの色を加算し、半透明の部
分に発光の効果があります。

**カラー
比較(明)**

下にあるレイヤーの色と、選択中のレ
イヤーの色を比較し、RGB数値の合計
の高い色が採用されて合成されます。

▶ その他

**オーバー
レイ**

選択中のレイヤーが下のレイヤーに比べて明るいところはスクリーン、暗いところは乗算の効果が得られます。明るい部分はより明るく、暗い部分はより暗く見えます。

**ソフト
ライト**

下にあるレイヤーと選択中のレイヤーの色が、明るい色同士だと覆い焼きのように明るく、暗い色同士だと焼き込みのように暗くなります。

**ハード
ライト**

下のレイヤーが選択中のレイヤーに比べて明るいところはスクリーン、暗いところは乗算の効果が得られます。

減算

下のレイヤーの数値から選択中のレイヤーの数値をマイナスにした色になります。

色相

上のレイヤーの色相を下のレイヤーに合成させるモードです。彩度・明度には影響しません。

彩度

下にあるレイヤーを、上のレイヤーの彩度にするモードです。色相・明度には影響しません。

レイヤーの使い方

レイヤーについて少しはわかってきたでしょうか。レイヤーを使いこなせるようになれば、お絵描きが一気に楽になります。

レイヤーの順番

レイヤーは、上下を入れ替えたり、好きに加えたり消したりすることができます。また、レイヤーは、上にあるレイヤーが下のレイヤーに効果を加えるように表示されます。そのため、お絵描きのときにも、基本的に、線画など作用されたくないレイヤーを上に、背景などほかのイラストよりも後ろに来るものを下に配置して描いていきます。せっかく描いていた絵が消えた！　というときは、表示させたいレイヤーが下になっていて、見えなくなっていた……なんてことも。

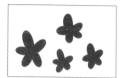

通常モードのままだと下のレイヤーは見えないように。

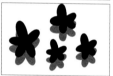

❶❷効果レイヤーはイラストの一番上に配置します。トーンカーブは全体の明るさや色味、明暗の比率を調節し、グロー効果はイラストを光らせる効果です。

❸ハイライトやホワイトは、線画より上におきます。

❹線画レイヤーは基本的に塗りで隠れないように上に配置します。

❺塗りのレイヤーは線画レイヤーより下にします。

❻背景レイヤーは人物レイヤーより下になります。

一番下にラフや下描きのレイヤーがありますが、隠れて見えません。完成時に消去します。

1枚のイラストにかかるレイヤーの枚数

レイヤーの枚数についてですが、これは人によるので、正解はありません。PCで絵を描いている人の中には、1枚のイラストを数百枚のレイヤーで描いている人もいれば、1枚だけのレイヤーで何度も色を重ねて描いている人もいます。

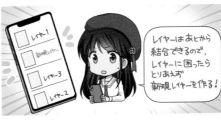

レイヤーはあとから結合できるので、レイヤーに困ったらとりあえず新規レイヤーを作る！

レイヤーを多くすることのメリットは、部分的な修正をしやすい点です。あとからミスが見つかったときなど、1枚のレイヤーにいろいろ描かれていると、一部直すだけでも結構な労力がかかります。また、パーツを動かしたいときなどにも、レイヤーがパーツごとに分かれていると便利です。

1枚のレイヤーで何度も色を重ねて、最後に線画を描くのが、いわゆる厚塗りという方法で、この場合、1枚しかレイヤーを使わないこともあります。

逆に、レイヤーが多いことの一番のデメリットが、処理能力の負担です。レイヤーが多ければ多いほど、描いている端末に負荷がかかるので、動きが遅く

なったり、急にアプリが落ちたりする可能性もあります。また、レイヤーが多いと、どのレイヤーに何を描いたのか、整理するのが非常に大変です。それぞれのレイヤーに名前をつけることはできますが、それだけでも時間はかかります。

スマホの場合はある程度完成した段階で、もう動かさないレイヤーを統合（合体させて1枚のレイヤーにすること）しながら、整理しつつ描いていくのがいいと思います。

レイヤーの便利な機能

ここではレイヤーについての便利な機能をご紹介します。といっても、機能は本当にたくさんあるので、なかでも、お絵描きのときによく使う機能をご紹介します。

レイヤーの表示・非表示

レイヤーは自由に見える・見えないを選べます。一時的にそのレイヤーを隠したいときはレイヤーの非表示を使います。通常は表示されている状態です。レイヤーを消去してしまうと元に戻せないので、とりあえず使わないレイヤーは非表示にしておくのがいいでしょう。

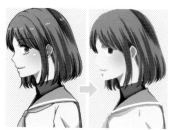

線画レイヤーを非表示にしてみました。

こういうときに使う！

・ペン入れのときに、なぞるレイヤー以外のラフレイヤーを隠したい
・複数人物を描くときに、一人ずつ描いていきたい

レイヤーの不透明度を変える

レイヤーは不透明度を変えることができます。通常は100%、つまりまったく透けない状態になっています。不透明度を下げる＝透明度が上がる、ということで、徐々に下のレイヤーに透けるようになります。レイヤーの色を薄くしたいときに使用したりしますが、線画や下塗りのレイヤーの不透明度を下げると、背景が透けたりするので注意です。

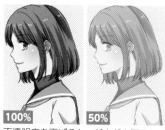

不透明度を下げると、だんだん下のレイヤーが透けて見えるようになります。

こういうときに使う！

・カゲを塗ったけど、もう少し薄めの色に変えたい
・ほんの少しだけわかる効果レイヤーを重ねたい

レイヤーをロックする

レイヤーのロック機能は、間違って描いたり消したりすることを禁止するための機能です。そのレイヤーをロックすると、そのレイヤーにさらに何かを描いたり、消したり、移動したりなどの行動がすべてできなくなります。

・間違って上描きすることを防ぎたい
・そのレイヤーは完成したからもう何も変更しないようにしたい

ロックされているレイヤーにペンを使おうとしても、何も描くことができません。

レイヤーの透明ピクセルをロックする

この機能は、ロック機能と似ていますが、描画部分・透明部分にかかわらずロックする前者と違い、そのレイヤーに描かれていない透明部分をロックするという機能になります。塗られている部分には、上から描いたり、消したり、色を変えたり移動させたりすることが可能です。

・そのレイヤーだけ色を変更したい・調整したい
・はみ出しを気にせずに何度も塗り重ねたい

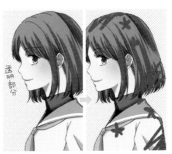

お絵描きで頻繁に使うのがこの機能です。透明な部分には描くことができない状態になっています。

レイヤーの統合と複製

レイヤーは自由に統合※（合成して1枚にすること）したり、複製（コピー）することができます。ただし、一度統合してしまうと、「取り消し機能」以外で元に戻せなくなるので、怖いと思ったらレイヤーを複製したのちに統合するといいでしょう。

※アプリによっては結合と呼ぶこともあります。

全てのレイヤーを統合

下に統合

クリア

ラスタライズ

左右反転

レイヤーフォルダ

レイヤーは、1枚1枚追加してそのレイヤーに描いていきますが、複数枚をまとめることができます。これがレイヤーフォルダです。

同じフォルダのレイヤーは、一括で管理することができます。フォルダを移動させればそのなかのレイヤーがまるごと移動しますし、表示非表示などもいちいちレイヤーを1枚ずつ切り替える必要もありません。

特に、1枚のイラストに複数の人物がいる場合などは、それぞれフォルダを作り、一人ずつ描いたりします。人物と背景を分けて描きたいときなどにも重宝します。

レイヤーフォルダは、最終的にフォルダ内のレイヤーを統合することもできますし、なによりレイヤーが多くなると大変見づらくなるので、整理するためにも、どんどん利用しましょう。

フォルダにまとめると見やすい！

フォルダを開くとこんな風に…

フォルダの中にフォルダを作ることもできます！

こういうときに使う！

・人物と背景などを分けて描きたい
・1枚のイラストに複数の人物を描きたい
・レイヤーをまとめて移動させたい

クリッピングマスク

クリッピングマスクは、下のレイヤーにつけることで、そのレイヤーに描かれている(塗られている)部分にしか作用しないレイヤーの機能となっています。下塗りレイヤーのカゲを塗るときなどに、はみ出さないために使用します。レイヤーの透明ピクセルをロックする機能にも似ていますが、その該当レイヤーではなく、別のレイヤーに透明ロックがかかっているような状態です。

↓クリッピングの印

クリッピングマスクは、複数枚のレイヤーを重ねてかけることができます。たとえば、肌の下塗りをしたレイヤーに、1枚目のクリッピングでカゲを塗って、2枚目のクリッピングで頬の赤みをつけるなど、それぞれレイヤーを分けてクリッピングすることが可能です。

赤い塗りレイヤーの上に、別のレイヤーで塗り重ねようとした例。下の赤い部分以外の透明部分に描くことはできません。

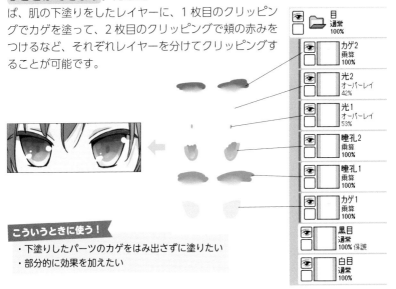

こういうときに使う！

・下塗りしたパーツのカゲをはみ出さずに塗りたい
・部分的に効果を加えたい

RGBとCMYK

RGBとCMYKという言葉を聞いたことがあるでしょうか。このふたつは、どちらも色を表現するしくみのことです。私たち人間は、光の波長の違いで色を認識していますが、その光を表現できるしくみがそれぞれ違うのです。

RGB と CMYK とは

RGBというのは、Red（赤）、Green（緑）、Blue（青）の光の3原色を混ぜて作り出す色の表現方法です（それぞれの頭文字をとってRGBと言います）。

主にデジタルのテレビ、パソコン、スマホで保存した画像や撮った写真はRGBデータとなっており、スマホで絵を描く場合も、基本的にはRGBデータとなります。なので、基本的になじみのあるモードがこちらのRGBモードとなるでしょう。

特徴としては、色が鮮やかで、発色の良いイラストを描くことができます。

RGB（加法混合）

CMYKというのは、それぞれCyan（藍）、Mazenta（紅色）、Yellow（黄）、Keyplete（墨板、いわゆるブラック）の4成分によって色を表現する方法です。自宅でプリンターを使う場合など、この4色のインクを買ったことがある人もいるのではないでしょうか。この4種類の色のインクを混ぜ合わせて色を作るため、混ぜれば混ぜるほど色は黒く暗くなっていきます。液晶ディスプレイなどで見られる明るい色などは、表現することができません。

CMYK（減法混合）

どう使い分ければいいの？

基本的にデジタルでお絵描きをしている場合は、最初から最後までRGBモードのままですので、特に気にする必要はありません。

RGB

たとえば、そのデータを使ってオリジナルグッズを作ったりする場合、自分が想定した色が出ない場合があります（基本的にCMYKにすると色は暗くなります）。

とはいっても、CMYKにする場合は、Photoshopなどの画像加工ソフトを使ったりしますので、スマホではなくてPCでの作業が必要になります。

自宅のプリンターやコンビニのコピー機は、RGBモードのままでもそのままCMYKに自動的に変換して紙に印刷してくれますが、たとえば同人誌や同人グッズを作るときに、印刷所に発注する場合は、こちらで予めCMYKモードに変換してからデータを送る必要があります。

CMYK

RGBとCMYKの色のちがいを伝えたいんですが

いかんせんここは紙の上…（すべてCMYK）

色相・彩度・明度

イラストを描くうえで欠かせない、色の話です。デジ絵は、色を塗ったあとからでも、色を自由に変えることができます。そのときに、この色相・彩度・明度という3つの属性を調整して色を変更したりします。

色の三属性

色は、「色相」、「彩度」、「明度」という3つの属性をもっています。色味を変えたり、配色を考えたり、色のバランスを整えたりするときに、この3つの属性をコントロールすることで、自由自在に色を使いこなすことができます。

▶ 色相

色相とは、赤色、青色、黄色、のような、色味の違いのことを言います。一般的に色が違うという概念は、この色相の違いのことを言います。色相を調整することで、同じイラストでも、全然違った配色をつくることができます。

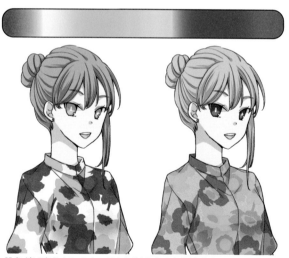

肌色だけ変えないまま、それ以外の色の色相を変えています。イラストの雰囲気を変えたいときに色相を調整してみるといいでしょう。

▷ **彩度**

彩度とは、色味の強さや、色の鮮やかさのことを言います。彩度が高いほど、色が明るく、はっきりとした色になります。逆に、彩度が低いと、だんだんとグレーに近づくように、くすんだ色になります。

彩度
低

彩度
高

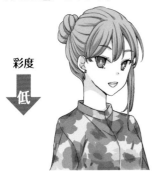

彩度
低

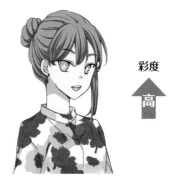

彩度
高

▷ **明度**

明度とは、色の明るさや暗さの度合いのことを言います。明度が高いと、明るくやわらかな印象で、どんどん白に近づいていきます。逆に、明度が低いと、暗く、どんどん黒に近づいていきます。

明度
低

明度
高

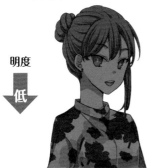

明度
低

明度
高

色は数字で表現される

スマホや PC で描くイラストは、RGB という色のしくみで表現されると述べましたが、具体的には、この R ＝ 赤、G ＝ 緑、B ＝ 青の数値で色がわかるようになっています。

普段はカラーパレットや色相環で色を選んだりしていると思いますが、どの色も、RGB の数値で決められています。

この RGB の数値は、0 から 255 までの 256 段階に分かれていて、すべての数値が 0 だと真っ黒、逆にすべての数値が 255 だと真っ白になります。

自分が気に入った色など、数値化しておいてその色をメモしておくのもいいでしょう。また、イラスト技法書などでは、紙面では正確な色がわからないので、数値で紹介している場合もあります。

また、この数値化は CMYK モードでもあります。

CMYK モードの場合は、各数値は 0 から 100 までの 101 段階となっていて、すべての数値が 0 だと真っ白に、すべての数値が 100 だと真っ黒になります。

ただし、CMYK の場合は、K がブラックに当たるので、K が 100 であれば、それ以外の CMY の数値がいくつであろうと、色としては真っ黒な状態です。

RGB モードは R と G と B の数値の組み合わせで色が表現されています。

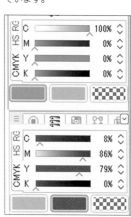

CMYK モードは、C と Y と M と K の数値の組み合わせで色が表現されています。

3章

デジ絵を
描いてみよう！

それではここからいよいよデジ絵を描いていきます。

多くの人が行っている人物イラストのオーソドックスな手順を紹介しますので、この章を参考に早速描いてみましょう。

デジタルイラストは、慣れれば慣れるほど描きやすくなるので、まずは、線を引くだけ、円を描くだけでも、とにかくチャレンジしてみてください。

まずは描いてみよう！

ここまで、いろいろなデジタルについてのお話をしてきましたが、まずは習うより慣れろ！ ということで、早速お絵描きアプリを起動してみましょう。最初はわからないことも多いですが、描いているうちに理解することも多くあります。

何でもいいから描いてみる

まずはキャンバスのサイズなどは気にせず、とにかく新規でファイルを作り、自由にいろいろ描いてみましょう。

レイヤーもいきなり使うのは難しいかもしれないので、まずは、ノートの落描きの感覚で、とにかく好きに描くのがいいでしょう。キャンバスがいっぱいになったら、消しゴムツールを使わなくても、レイヤーを消去すればいいだけです。

まずはとにかく慣れるのが大事です。最初は難しくて思うように描けなくても、毎日触れる機会を作りましょう。

取り消しボタンを使ってみる

デジ絵で大変便利な機能に、「取り消し機能」というものがあります。PC では Ctrl+Z というショートカットで、作業していた直前のアクションを取り消して、そのひとつ前の状態に戻すという機能になります。

ペンツールで描いていたらそのひと筆分が消されますし、レイヤーを移動させていたら、元の場所に戻ります。取り消しボタンを何度も押すことで、どんどん前の状態に巻き戻すことができます。

いろいろなブラシを使ってみる

　少し慣れてきたら、次にブラシを変更してまた描いてみましょう。アプリにもよりますが、それぞれ多くのブラシが備わっているので、試しながら自分に合うブラシやペンツールを探してみてもいいでしょう。

同じ線画でも、ブラシツールや、ブラシの太さで、出せる印象は変わります。左がGペンツール、真ん中が鉛筆ツール、右がマーカーツールで描いた線画になります。

デジ絵ならではの機能を使う

デジ絵に慣れてきたら、次にいろいろな機能を使ってみましょう。補正機能は、デジ絵にしかない大事な機能です、上手く描けるようになるために使えるものはどんどん活用していきましょう。

▍手ブレ補正をつける

デジ絵は、まっすぐ線を引いたつもりでも、どうしても線にゆがみが出てしまいます。線を引くことに慣れていない初心者ならなおさらです。そういうときに、線のゆがみをきれいに調節してくれるのが「手ブレ補正」という機能になります。ガタガタになった線を整った線にしてくれるので、まずはこちらを設定しておきましょう。

補正が強くなりすぎると、自分の思ってた以上に線がさらっとしてしまうこともあるので、調整しながら自分なりの数値を決めてみてください。

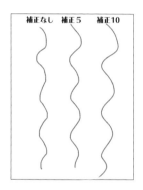

▍入り抜き補正をかける

アナログのマンガ用つけペンで線を引くと、力の入れ具合によって、線に強弱をつけることができます。この描き味にできるだけ近づけるような線を引きたいときには、「入り抜き機能」を使います。

これは、線の最初と最後を、徐々に力を入れていくように、また徐々に力を抜くように自動的に調整してくれます。スピード線を引きたいときや、マンガらしい線を描きたいときには、とくに重宝する機能です。

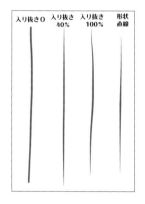

レイヤーを使ってみる

第2章で解説したレイヤー機能を使ってみます。新規キャンバスを作った時点で、レイヤーは1枚あります。さらに1枚レイヤーを加えて、色をつけたり、カゲを塗ったりしてみましょう。

複数のレイヤーを使えるようになったら、実際にフルカラーのイラストにチャレンジしてみます。

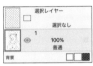

人物の線画が描かれた1枚だけのレイヤーになります。

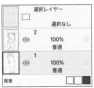

レイヤーを1枚加えて、人物の線画を上に移動させます。濃い色になるところを一色で塗ってみました。

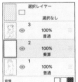

さらにレイヤーを重ねて、カゲをつけてみました。塗りに重なる箇所が出てくるので、黄色がピンクをつぶさないように、黄色のカゲは乗算レイヤーにしています。

57

線の練習をしよう

はじめてのデジタルイラストは、思った以上に描けないことに驚いた方も多いのではないでしょうか。鉛筆＆紙に比べると、自分が思い描く線が全然引けない……これは誰もが通る道です。

きれいな線画を描くにはまず線の練習から

スマホで完成度の高いイラストを描くために最も大事なこと、それは「きれいな線を引けるようになること」です。

PCやタブレットでお絵描きをする場合、最初は少しとまどうかもしれませんが、ペンを使って、アナログと同じようになめらかな線を引くことはそう難しいことではありません。画面も大きいですし、のびのびとした線を引くことができます。しかし、スマホだとそうはいきません。限られた画面で、ちまちまと線を描いていくことになります。

そして線がガタガタかまっすぐになっているか……その違いはイラストの完成度に大きく影響します。まずは、ペンとキャンバスに慣れるためにも、きれいな線を引く練習をしましょう。

ひたすら線を引きます。線画が整えば、塗りが多少雑でも、きれいなイラストに見えます。

勢いよく線を引く練習を

では、どんな風に練習すればいいでしょうか。

やり方は、いたってシンプルです。ひたすらまっすぐな線を引き続けるだけです。しかし、これが意外と難しいのです。

ゆっくり線を引くほどガタガタになりやすいので、線を引くときは思い切りが大事です。スピードよくシャッシャッと引いていきます。筆圧の使い方で線の強弱もつけられるので、最初は均一の太さでも構いませんが、徐々に強弱をつけてみましょう。また、最初は短い線で、少しずつ長い線を一息で描けるようにします。

均一で同じ長さの線が引けるようになるまで、ひたすら線を引き続けます。上から下に線がきれいに引けるようになったら、下から上、左から右、斜め……と、いろいろな角度から線を引き続けます。

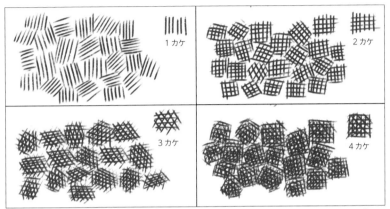

いろいろな角度から線を引くときに、練習になるのが、カケアミを描くことです。一線だけの1カケ、縦横の2カケ、横線と、その線と60度になるように斜線を交差させる3カケ、そして2カケを重ね合わせた4カケ。いろいろなカケアミを整って描けるようにひたすら線を引いてみましょう。

直線の次は曲線

　きれいな直線が引けるようになったら、次は曲線です。円を描いたり、曲線を引く練習をしましょう。きれいな円が描けるまで続けます。

　曲線については、描きやすい角度の線ができるかもしれませんが、それで構いません。苦手な角度を描くよりは、描きやすい線を伸ばしていけばいいのです。

　とにかく、短い線よりも、長い線を一息でなめらかに描けるようになるまで練習することをおすすめします。

人物イラストの基本工程

デジタルのお絵描きに慣れてきたら、実際に人物を描いて、まずは1枚、イラストを完成させてみましょう。

イラストを描く手順

　あなたはこれまでノートやスケッチブックに絵を描いてきたとき、どういう手順で描いてきたでしょうか？　鉛筆だけで落描きをしていた程度？　それとも、本格的に絵を描くときは鉛筆で下描きを描いて、つけペンでペン入れをしていましたか？

　デジタルイラストの場合でも、その根本的な手順は同じです。まずはラフを作り、下描きを描きます。その下描きを上からなぞるようにしてペン入れをします。そのあと色塗り……というふうに進めていきます。

人物イラストの
手順

❶ ラフを描く

❷ 下描き

❸ ペン入れ（線画）

❹ 下塗り

❺ カゲ塗り

❻ ハイライト

❼ 加工・調整

キャンバスサイズを決める

描きたいサイズのキャンバスを決めましょう。サイズが特に決まっていない場合は、できるだけ大きめのキャンバスを選ぶほうがいいでしょう（幅と高さともに 1000pixel 以上が望ましいです）。

スマホで見ている場合、キャンバスを選んだ直後はぱっと見、500pixel も 1000pixel も同じように見えます。それは、見えている表示が自然に縮小・拡大されているからです。

100％の原寸で見たときに、大きさの違いがわかるでしょう。

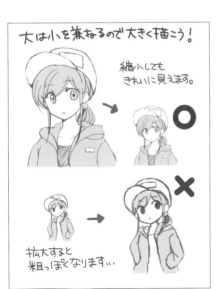

慣れるまでは大きさなどにこだわらなくても構いませんが、キャンバスが小さいと、どうしても細かい絵を描くのが難しくなります。

また、大きすぎると思ったらあとから縮小もできるので、最初は大きめに作っておきます。小さいキャンバスから大きいキャンバスに拡大すると、粗が出てしまうので、まずは大きめのキャンバスを選んでおくと後々対応しやすくて安心です。

61

1 ラフを描く

まずはイラストのラフを描いていきます。ここは拡大せず、キャンバス全体を見ながら、人物の大きさなどを決めます。

ペンはどんなブラシでもいいですが、色は、何度もラフを描くことを考えて、黒以外の色がいいですね。

ラフは、きれいな線になるまで、少しずつ細かく描いていきます。

まずはざっくりとした顔の大きさと体の大きさ、キャンバスをどう使うかを決めます。最初は、きれいな線でなくてもいいので、全体がわかるようなラフを描きましょう。

まずは100%の原寸の状態で、ざっくりとした配置を描いていきます。全体のイメージを描く程度です。

レイヤーを重ねて、今度は目の大きさ、髪など、徐々に細かいラフを作っていきます。

レイヤーを重ねて、下のレイヤーの透明度を下げます（描いたペンの色を薄くするためです）。

透明度を20～30%くらいまで落として、さらに上からラフを描きます。

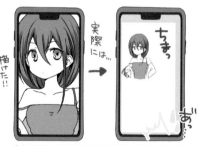

全体表示と部分拡大をくり返す理由ですが、ずっと拡大して描いていると、それが原寸で見たときに、思った以上に小さかった、大きかった……ということを防ぐためです。

その際に、わかりやすくするために別の色を使うのをおすすめします。今度は、大まかな目の位置や髪の流れなどを描きます。拡大と全体表示をくり返して、バランスが崩れないように気をつけます。

レイヤーを重ねて、同じようにもう少し細かいラフを描きます。

徐々に細かく描き込む作業を、納得いくまで何度もくり返します。

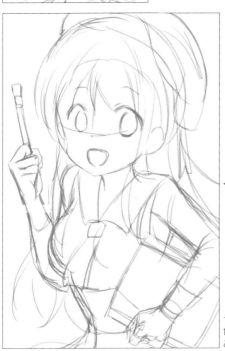

Point !

ラフは何枚もレイヤーを
重ねながら徐々に細かく
描いていく！

ラフができました。ラフの段階で
色のイメージも塗っておく場合も
あります。

2 下描きを描く

　ラフと下描きの違いですが、厳密にはあまり具体的にどう違うという定義はありません。ペン入れの準備段階という意味ではどちらも同じです。

　本書では、ラフはざっくりとしたイメージ段階、下描きはそのままペンでなぞれるように描き込んだ状態、とします。

ラフからより細かく正確に描きます。

　ラフからさらにレイヤーを重ねて、できるだけ細かく描き込んでいきます。

　ここまで細かく描く理由ですが、ペン入れの際に、できるだけ線で迷わないようにするためです。

迷い線が多い絵は、線が少ない絵よりうまく見えることがあります。これは脳内で一番いい線を勝手にチョイスしてくれているからです。
ただし、迷い線の多い下描きは、実際にペン入れをするときに、どの線を描けば……と悩みながら描くはめになります。

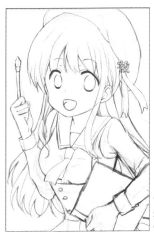

ペン入れは、自分が思う線が描けるまでキャンバスを拡大して、基本的にパーツごとに描いていくことになります。特にスマホの場合、きれいな線を引くために拡大すると、画面上で見えている部分がかなり狭く、その状態で少しずつペン入れしていくわけです。

ですので、全体のバランスを見ながらペン入れで調整しながら描く……というのがとても難しいのです。

下描きもペン入れしやすいように、赤、青、緑など明るめの色で描くのがおすすめです。

結果、それぞれのパーツはきれいに描けていても、全体のバランスが崩れてしまいがちです。

それを防ぐために、まずは全体のバランスを含めて下描きでしっかり描いた状態で、ペン入れを「線をなぞるだけ」の作業にすることで、迷いない、きれいな線を描くことができます。

Point！

ペン入れはなぞるだけで描けるようにする！

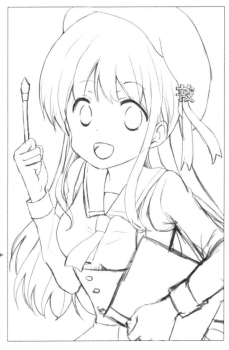

下描き完成！

3 ペン入れをする

　下描きが終わったら、ペン入れの工程に進みます。線を描くときに迷わないようにするため、下描きレイヤー以外のラフレイヤーなどはすべて消去するか、非表示にします。

　ペン入れはできるだけ丁寧に、思ったような線が引けるまで何度もやり直します。また、バランスがおかしいと思ったら、適宜目の位置を移動させたり、描き直したりと、その都度調整していきます。

　常に全体と部分を行き来してバランスを見ながら描くのが大事です。

自分がきれいな線を引けるギリギリまで拡大して描いていきます。

ラフ～ペン入れで使える機能

ラフ～ペン入れで使えるデジタルならではの便利な機能は、どんどん使っていきましょう。

左右反転…右向きの顔、左向きの顔など、苦手な方向がある場合は、あえて描かないという選択肢もあります。デジタルは反転ができるので、得意な方向だけ描けばいいのです。

回転…これはアナログでもできますが、キャンバスを動かすことで、引く線を常に自分の得意な角度だけで描き続けることができます。

下描きレイヤーの上にペン入れ用のレイヤーを重ねます。ペン入れの場合は、黒や濃い茶色を使います。黒の場合、ぱきっとしたアニメ調のイラストに仕上がります。茶色の場合、少しふんわりとした柔らかめのイラストに仕上がります。

黒
濃茶
グレー
パーツごと

ペン入れに使う色も、人によってさまざまです。茶色やグレーだとふんわりした印象になりますし、パーツごとにペンの色を変えている人もいます。

　ペンツールに関しては、それぞれ人によって合う合わないがありますので、使いながら自分に合うペンを探してみてください。

　Gペンは線の強弱がつけやすく、勢いのある線になります。丸ペンは全体的に細目で、繊細な線を描けます。顔の輪郭やGペン、髪は丸ペン、などのように、部分的にペン先を変えてもいいでしょう。

　また、ペン入れだからといってペンツールにこだわる必要はありません。鉛筆でペン入れをすると、全体的に柔らかい印象になります。筆ツールも同様です。自分に合うツールで描けばいいのです。

ペン入れ完成です。

67

4 下塗りをする

　ペン入れが終わったら、ついに色塗りになります。ペン入れレイヤーの下に色塗りレイヤーを重ねていきます。

　下塗りは、部位ごとにレイヤーを分けておくと、あとから便利です。たとえば、カゲを塗ったあとから色を変えたくなったり、描き直したくなって塗り直しが必要になったときなどに役立ちます。肌の下塗り、髪の下塗り、といったように、とくに隣接部分はレイヤーを変えておくといいでしょう。

下塗りレイヤーの
パーツ分けの例

⑪ 線画

⑩ 小物など
（筆・スケッチブック）

⑨ バッジ

⑧ ボタン・タイ

⑦ スカート・帽子

⑥ シャツ

⑤ 目

④ 髪

③ 口

② 白目

① 肌

下塗りレイヤー分けの例です。パーツごとにレイヤーを分けておきますが、細かいパーツは、ある程度まとめてもいいでしょう。レイヤーが多いほど、管理が大変になりますし、データが重くなってしまうからです。

下塗りレイヤーの順番

下塗りレイヤーのレイヤー順ですが、下にあるパーツはややはみ出すように、上のレイヤーではみ出し部分を消すようにすると、隙間なく塗ることができます。そのため、肌の上に髪レイヤー、その上に帽子のレイヤーという風に重ねていきます。

バケツツールのポイント

バケツで下塗りするときは、ペン入れの時点で、線と線の隙間をなくしておくことが重要です。隙間があると、バケツが使えません。
あえてペンで隙間を作りたい場合は、下塗りレイヤーにペンでその隙間部分をふさいでから、バケツを使いましょう。

5 グラデーションをつける

　カゲを塗っていく前に、下塗りにグラデーションを加えていきます。グラデーションは、大きめのサイズのエアブラシツールでさっと塗る感じです。グラデを入れることによって、立体感を出すことができます。ほかにも、色味を増やしたり、イラストに鮮やかな印象を加えることができます。

頭部の丸みを出すために、額から濃いピンク、ほかにも肌パーツにグラデを入れます。

髪は頭頂部から、毛先から、それぞれ中央に向けてグラデを入れます。それ以外に中央に明るい色を入れると、空気感を出すことができます。

白目、黒目、それぞれグラデを入れています。

奥になる箇所（凸凹の凹のほう）を濃くするようにグラデを入れます。

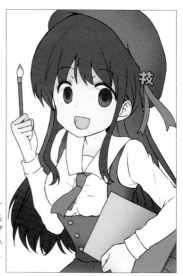

グラデは主張しすぎないように、あくまで下塗りのプラスアルファという程度にしましょう。

70

番外編　目を塗る

　目の塗りは、イラストレーターによって様々ですので、自分の好みのイラストの真似をするのがいいと思います。一例としてこのイラストの目の塗りを解説します。第4章にも目の塗り解説がありますので参考にしてください（99〜100p、138〜139p）。

①

乗算レイヤーで瞳部分を塗りつぶし、上からグラデをかけます。

②

同じことをくり返しますが、瞳、グラデそれぞれ範囲を小さくします。加えて、目の下周りもグラデを入れます。

③

瞳の真ん中を明るい色で塗り、瞳の上部に反射光として暗めの色を塗ります。

④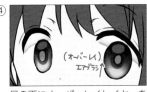

目の下にオーバーレイレイヤーを重ねて、明るい色(今回は水色)でグラデを入れます。

⑤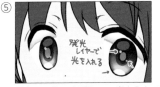

発光レイヤーを重ねて、光を入れていきます。

⑥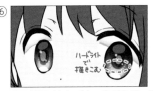

ハードライトレイヤーを重ねて、瞳の周りに線を加えます。

⑦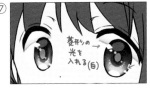

最後に、全体の一番上にレイヤーを作って、ホワイトを入れます。丸だったり菱形だったり、好みで入れて完成です。

6 カゲをつける

　下塗りができたら、カゲをつけていきます。カゲは、それぞれ分けたパーツにレイヤーを重ねて塗っていきます。

　また、カゲは 1 回目、2 回目……と、何度か分けて塗っていくと、より立体的なイラストに仕上がります。ですので、1 カゲはやや薄めに、2 カゲはやや濃いめに……というように塗り重ねていきましょう。

カゲは、まずはペンツールでアニメ塗りのようにかっちりと塗っていき、毛先をぼかします。ぼかすことで、下塗りの色となじませることができます。

カゲを塗る色に迷った場合は、下塗りの色から少し明度をあげた色をチョイスして、その色を乗算レイヤーで塗ります。慣れたら、全然違う色をカゲ色に使ってみても、おもしろい効果が出るでしょう。

1 カゲが塗り終わりました。まだ全体的にふんわりした印象なので、もう一段階カゲを塗っていきます。

1つのパーツのレイヤー内訳

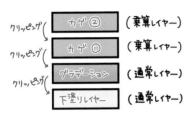

カゲを塗るレイヤーは、それぞれ、下塗りレイヤーの上に重ねていきます。はみ出さないように、クリッピングしておきましょう。

2カゲは、1カゲをさらに強調するために塗りますので、1カゲを塗ったところの中から塗ります。範囲も、1カゲよりは狭めに塗ります。

Point !

イラストによっては3カゲ、4カゲと重ねてもOK！

カゲが塗り終わりました。カゲの境界線に濃い色を入れることで立体感が出ます。

7 ハイライトを入れる

　ハイライトとは、いわゆるホワイト、光の表現です。全体の一番上にレイヤーを作って、光を入れていきましょう。肌や髪、服など、カゲと光はセットで考えていきます。

髪のツヤは、頭の丸みを意識してハイライトを入れます。

頬に赤みをつけて、その上に光を入れます。

金属部分には、コントラスト強めのカゲと光を入れます。

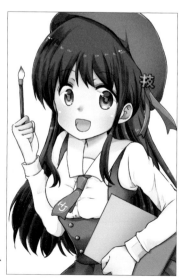

完成です。ホワイトを入れることで、立体感がさらに加わります。

番外編　そのほかのパーツを塗る

　カゲで塗ったあと、ハイライトを入れる前後で、そのほかの細かいパーツを完成させていきます。

前髪に明るい肌色のグラデを入れます。こうすることで顔が明るく見えます。

髪の毛を描き加えます。房だけではなく毛があると、髪のリアル感が出ます。

スケッチブックの金具を描いたり、文字を入れました。

ちょっとした微差の積み重ねが、イラストのクオリティを変えるんですよ。次ページからの加工も同様です。

8 調整・加工をする

　このまま完成でもいいのですが、デジタルイラストはいろいろな加工ができます。おもしろい効果もつけたりできるので、いろいろ試してみてください。今回はオーソドックスな加工をします。

すべてのレイヤーを統合して、色を濃いめに調整補正します。くっきりとした色合いになります。

そのレイヤーを複製して、オーバーレイレイヤーにして、不透明度を50%に下げます。これで、肌などの明るい箇所はより明るく見えるようになりました。

ノイズテクスチャを上に重ねます。

テクスチャレイヤーをオーバーレイに変更し、不透明度を30％程度に落とします。画用紙に塗ったような効果が得られます。顔や肌などは荒れてきれいに見えないので、その部分だけテクスチャを消します。

完成です。もちろん、絵の描き方、塗り方は人それぞれで、これが正しい！ というも
のはありません。あくまで一例として、参考にしてください。

そのほかの加工

加工はイラストの目的やイメージに合わせて、いろいろな方法があります。その一例をご紹介します。

ぼかし

　線画レイヤーを複製して、複製したレイヤーにぼかしを入れます。そのままだと線画が太く濃くなるので、元の線画レイヤーと、ぼかした線画レイヤーの不透明度を少し落として完成です。ぼかしを入れたことでふんわりとしたイラストになります。

グロー効果

　統合したイラストを複製して、レベル補正で色を濃くし、さらにぼかしを加えます。そのレイヤーをスクリーンモードにすると、キャラが光っているような効果になります。必要に応じて不透明度を落としてください。

オーバーレイ

統合したイラストを複製して、透明ピクセルをロックし、好きな色に塗りつぶします。そのレイヤーをオーバーレイモードにして不透明度を落とすだけです。全体の色の雰囲気を変えることができます。顔などの肌部分だけは血色の良さを生かすために消しておきましょう。

オーバーレイモードのレイヤーは、1色で塗りつぶしても、上記のようにグラデにしてもおもしろい色のフィルタになります。

色収差

統合したイラストを複製して3枚作ります。それぞれ赤緑青（赤はR255、緑はG255、青はB255）で塗りつぶした乗算レイヤーを結合して、上の2枚をスクリーンモードに変え、それぞれレイヤーの位置をずらすとちょっと色がぶれたような効果を出すことができます。

わかりにくいかもしれませんが、キャラの横に緑色の主線がぼやっとして見えます。印刷ミスではなく、そういう効果を狙っています。

初心者が陥りがちなミス 8選

はじめてデジ絵を描いてみた！　でも、思ったように描けない……という、お絵描き初心者にありがちなミスを集めてみました。ちょっとした工夫で絵がよくなることはありますので、参考にしてみてください。

1 一本の線が短すぎてゆがんだ線に見える

失敗… ✕ ペン入れをするときに、きれいな線を引こうとしても、長い線を一息で描けない人は、短い線をつないで線を作ることになると思います。
しかし、短い線をつないでいくと、結果的にゆがんだ線になったり、線と線の間に隙間ができたりしてしまいます。

改善策！ 思い切った線が引けるようになるまでできるだけ線のみで練習するのが理想です。角度が変わるところまではできるだけ一息で描きましょう。
とくに曲線部分は、自分の得意な線を引けるように、画像を回転させて、得意な角度だけでペン入れしていくのもいいでしょう。また、できるだけ拡大した状態でペンを入れていくと、引いてみたときに、線のゆがみが気にならなくなります。

2 ペン入れの線が単調になってしまう

失敗… きれいにペンを入れようとして、丁寧かつ慎重にペンを入れていったら、線画が細く単調になってしまった、ということもあります。

単調な線画だと、色を塗ったときに、線が色に負けてしまったり、キャラの躍動感や動きが感じられなくなってしまいます。

改善策！ 線の強弱を強めるには、Gペンなど線に強弱を出しやすいペン先を使用することです。輪郭線は太く、服のシワなどの細い線は細く描いていきます。筆圧で強弱を出すのが難しい場合は、ペンの太さを変えながら描いていくのもいいでしょう。

また、太くしたい線を重ね描きしたり、線と線が交わる箇所を上から描き重ねたりする方法もおすすめです。交差してる箇所を少し太くすることで、メリハリのある線画にすることができます。

3 ペン入れをしたあとに線を直したくなる

失敗… ペン入れが終わった！……ですが、ちょっと時間をおいてもう一度見てみたら、あれ、ここがちょっとおかしい、ここも直したい、ということはままあることです。ですが、そういうときに、たとえば目を直そうとしたら髪まで消すことになったり、目だけ選択して移動しようとしてほかの部分もついてきたり、結果大部分が描き直し……なんてことも。

改善策！ ペン入れをしたあとに修正したくなる人は、少し手間ですが部位ごとにペン入れレイヤーを分けておくといいでしょう。
とくに目や髪については、ほかの顔パーツと被ったりするので、そこだけの修正や移動ができません。目だけのレイヤー、髪だけのレイヤーと分けておいて、完成したらあとから結合するのがいいですね。

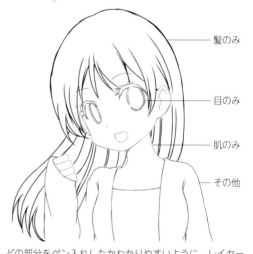

髪のみ

目のみ

肌のみ

その他

どの部分をペン入れしたかわかりやすいように、レイヤーごとに色分けしておくとさらにわかりやすいです。

ペン入れと下描きを同じレイヤーに描いてしまう

失敗… デジタルイラストを描いている
人なら誰しも一度は遭遇するミ
スです。

ペン入れしているときは気づかずに、線画
が完成したあとに、同じレイヤーだったと
気づくパターンです。線画の描き直しはと
ても面倒……できるだけ避けたいですよね。

↑
下描き線を
消そうとして
気づくパターン

改善策！ ペン入れに入る前に、下描きのレイヤーの透明度を下げておくの
がおすすめです。

そうすることで、そのレイヤーにペンを入れたときに「薄いな！」って気づくこ
とができます。下描きを最初から薄めの色で描いてしまうと透明度を下げにく
いので、下描きはしっかりとした色で描くといいでしょう。

同様に、ペン入れも黒などできるだけ濃い色にしておきます。色はあとから違
う色に変えることもできるので（レイヤー状態を保護したうえで別色で塗りつ
ぶす、もしくは色調補正を使う）下描きの色と見分けられる色にします。

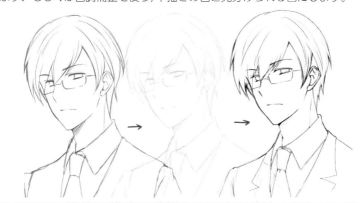

5 下塗りの塗り残しが多い

失敗… 下塗りでバケツツールを使わず自分で塗る場合、ちゃんと塗ったつもりでも、白い部分が残ってることがあります。またバケツツールを使ったときも、毛先や線と線の隙間など、塗り残しがでてしまいます。普通に引きの状態だと見えないので気づかないこともあります。

拡大

改善策！ 下塗りをしたあと、拡大して(100%以上)塗り残しをチェックして、手作業で塗っていきます。バケツツールの場合、線が描かれている箇所は塗られないので、一度線画レイヤーを非表示にして、塗り残し部分をチェックしましょう。

線画を非表示にする

隙間を塗りつぶす

線画を表示する

6 肌色を肌色として塗ってしまう

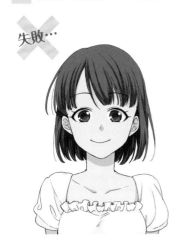

失敗…

立体的なイラストを描くには、基本的に
下塗り→カゲをつける、という工程にな
りますが、下塗りの段階で、完成された
色を塗ってしまうと、そのあとカゲが塗
りにくくなります（濃くなってしまうの
で）。
特に多いのが肌色で、肌色を絵の具の肌
色のように塗ってしまうと、色白美少女
のはずが肌の色が濃すぎる……なんてこ
とも。

下塗り　　カゲ

改善策！

最初の下塗りは、イエローベースやピンク
ベースで薄めの色を塗って、そこからやや
濃いめのカゲ色をつけることで肌を表現し
ていくのがいいでしょう。肌色を使わなく
ても、肌を表現することは可能です。
同様に、黒髪なども、最初から真っ黒に塗
るのではなく、グレーで下塗りを入れて、
そこからグレーでさらにカゲをつけていっ
て濃淡を表現しましょう。

下塗り　　カゲ

85

7 エアーブラシを多用しがち

失敗… エアブラシは、ほんわかした印象を出せますし、アナログ勢には新鮮なブラシなので、つい楽しくて使ってしまいがちです。

とくに、立体的に塗ろうとしてカゲをエアブラシで塗ったり、下塗りも含め、すべてエアブラシで色をつけてしまうこともあります。

しかし、エアブラシを多用してしまうと、ぼんやりとしたイラストになりますし、細かいカゲの塗りなどができなくなります。

改善策！ エアブラシだけで色を塗るのではなく、あくまで補助として使うのがベターです。

エアブラシは、サイズを大きくして、ぽんっとのせるように塗るとグラデーションのような効果を出せます。これを利用して、下絵のグラデーションとして使ったり、肌の立体感を出すために使ってみましょう。

それ以外にも、頬の赤みや、加工時に使用することもあります。

8 カゲをグレーで塗りがち

失敗… 人物のカゲは、基本的に下塗りレイヤーとは別のレイヤーで塗ることが多いですが、乗算モードで塗る場合、グレーの色で塗ると、単純にその色を暗くすることができるので、よく使われがちです。ただ、イラストの場合、グレーばかりでカゲを塗っていると、単調なイラストになってしまいます。

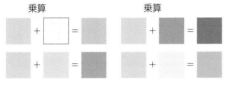

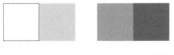

改善策！ グレーだけではなく、それぞれの下塗りの色に合わせたカゲ色を使っていきましょう。カゲに困った場合は、同系色のやや暗めの色を選ぶと安定します。
白い服のカゲも、グレーではなくて水色っぽいものを使うなど、一工夫するとイラスト自体が明るくなります。

イラストの保存について

スマホでイラストを描いていると、基本的には途中で描くのをやめても、作業中のイラストは自動的に保存されていて、次回アプリを開いたときには前回の状態から復帰できるようにしてくれています。

ただし、PCでイラストを描く場合は、途中段階でも保存しなければ、データは残らないので注意が必要です。

突然PCの電源が落ちたり、ソフトが強制終了したりすることもあるので、「こまめに保存」はPCでは必須となっています。

いずれPCでお絵描きしたいと思っている人は、スマホでも保存は習慣づけておきましょう。また、上書き保存だけでなく、別名で保存して、途中段階のイラストを残しておくと、そのあと作業して、やっぱり前の状態に戻したい、と思ったときに、その保存しておいたデータを使えるのでいくつかデータを分けておくのもおすすめです。

保存しないままアプリを閉じても、自動的に保存されているので復帰できます。

レイヤーを統合してしまうと元に戻せなくなるので、統合前に、イラストの複製や別名保存の機能で、結合前の状態のイラストを残しておくと安心です。

PCでは皆一度は必ず陥るこの悪夢……。

4章

デジ絵イラスト
メイキング

ここからは、3枚のイラストのメイキングを紹介します。

お絵描きアプリはすべてアイビスペイント、なかでも最初の2枚は指で描かれたイラストとなっていますので、スマホでお絵描きが上手くなりたいと思ってる方はぜひ参考にしてみてください。

最後の1枚は、iPadで描かれたイラストですが、同じアプリの機能を使いつつ、タブレットだとさらに細部まで描ける点や、なめらかなペンの線など、より発展したイラストを描きたいというときの目標にぴったりです。

スマホで本格的なイラストを描くときの心構え

3名のイラストメイキングの前に、まずはスマホで本格的なイラストを描くときに注意しておくこと、理解しておくことをまとめておきます。

スマホで描けるメリットとデメリット

スマホでお絵描きができるようになったとはいえ、もともとスマホはお絵描き用の機体ではありません。

手軽で、どこでも描けるし、アプリも無料でダウンロードできるから誰でもデジ絵が描けるようになったとはいえ、もちろんデメリットもあります。

まずは、そのメリットとデメリットを改めてしっかり認識しておきましょう。

▶ メリット

①無料でデジ絵が描ける

PCやタブレットを買うお金がない人にとって最大の味方です。

スマホさえあれば、誰でもデジ絵にチャレンジすることができます。ペンですら指で代用できてしまいます。

②豊富なお絵描きアプリ

イラストを描くためのアプリも複数リリースされています。無料で使えるものでも十分なツールや素材が用意されています。

③いつでもどこでも描ける

スマホさえあれば描けるので、場所を選びません。

▶ **デメリット**

①液晶画面が小さい

　これが一番のデメリットで、スマホの液晶画面は、タブレットよりもずっと小さく、本格的なイラストを描くのには不向きです。

　特に細かい部分の描き込みなどがとても難しいです。

②筆圧が感知しにくい

　タブレットや液タブのような、本当に紙に描いてるような描き心地ではありません。ペンの強弱がつけにくく、ペンも鉛筆のようになめらかに描けるベストなものはなく、どうしても自分が思ったような線を描けるには時間がかかります。ある程度自分が妥協して、慣れる必要があります。

③データの重いイラストを描きづらい

　レイヤーを増やせば増やすほど、サイズを大きくすればするほどイラストのデータサイズは大きくなります。その分動作もゆっくりになったり、動きづらくなってしまいます。マンガなども描けますが、解像度の高いイラストを描くのもあまり向いていません。

PCやタブレットのイラストには敵わない

　スマホのお絵描きは落描きや、ちょっとしたイラストを描くには十分足りますが、たとえば本格的にイラストを描きたいという人や、壮大なイラストを描きたいという人、もしくはプロのイラストレーターを目指す人は、現段階では、やはりPCやタブレットでのお絵描きをおすすめします。

　もちろん金銭的なことも含め、今すぐ環境を整えるのは難しいという人も多いと思いますが、あくまで、本気で絵が上手くなりたい人は、今後そういう環境を目指すことを考えておいてください。

お絵描きだけでなく、たとえばインターネットの検索画面などを比較するだけでも、スマホとPCの差がわかると思います。PCのほうでは、同時にウインドウをいくつも開けますし、目に入る情報が段違いなのです。

スマホでクオリティ高いイラストを目指すには

　そのうえで、できるだけスマホで本格的なイラストを描きたいならどうするべきか？

　それは、「**多くの手間と時間を惜しまないこと**」です。

　PC で描くよりもずっと多くの手間と時間をかけることで、細かい部分の描き込みなど、どうしてもスマホでは不向きなところを、できるだけカバーすることができます。

　具体的にどのような手間をかけるかというと、本書でもくり返しお伝えしていますが「できるだけ拡大して少しずつ完成させる」ということです。
　等倍のままでは、どうしても細かな部分が描けないので、そういう部分は、200％、300％、400％と、できるだけきれいな線が描けるまで拡大して、少しずつ丁寧に描いていきます。
　まずはなめらかな線が描けるようになるまで線の練習をしてから、そのなめらかな線を線画で表現できるくらいまで拡大して、少しずつ描き進めましょう（といっても、丁寧に線を引いていると、それはそれで硬い線になってしまうので、ある程度の勢いは大事です）。
　根気は必要ですが、拡大して少しずつ描いていくという手法は、PC やタブレットで絵を描くようになったとしても必ず役に立ちます。
　クオリティの高いイラストは、プロでも簡単に描けるものではなく、本格的なイラストは 1 枚に何十時間もかかってることもあるのです。

　そうして描かれた作品が次ページからのイラストメイキングになります。最初の 2 枚はスマホで描かれたものですが、どちらも制作時間が 19 時間と、かなりの長時間大作となっています。いい絵を描こうとするならば、それなりの時間をかける覚悟をもって、是非メイキングを参考にしながら、素敵なイラストを描いてみてください。

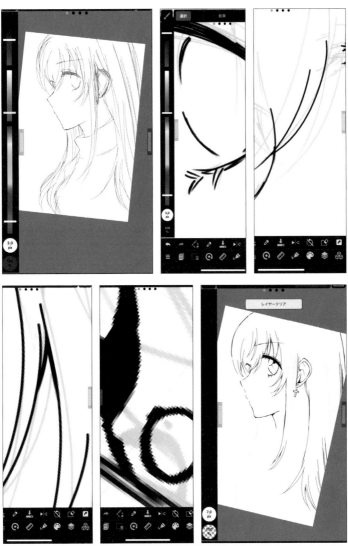

描けるまで拡大し、少しずつ線を整え、また全体を見る。また拡大し、パーツを少し
ずつ描いて、また全体を見る。この作業のくり返しになります。イラストを完成させ
るには根気が何より必要です。

第4章

93

透明感のある人物イラストを描く

イラストレーター：水鏡ひづめ　使用ソフト：アイビスペイント
使用端末：iPhone11　制作時間：19時間18分

1 ラフを描く

まずはじめに、イラストを描くにあたってテーマを決めます。

今回のイラストは振られてしまった女の子をテーマに、泣きながらも強がって笑っているというコンセプトでイラストを作成しました。

構図を決める際に、どうやったら女の子の魅力を最大限に引き出せるかを考え、髪の毛をふんわり持たせる構図にしました。

ラフができたら、ペン入れをしていきます。

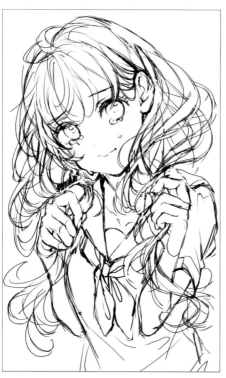

— Point ! —

髪のペン入れは次ページで解説！

　髪の毛は、手前の髪、中間の髪、奥の髪という3つのレイヤーに分けておきます。

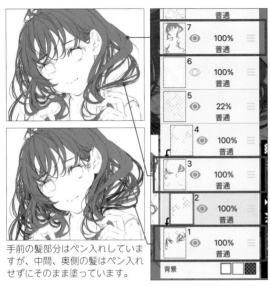

手前の髪部分はペン入れしていますが、中間、奥側の髪はペン入れせずにそのまま塗っています。

それぞれの髪を塗ったレイヤーの上に新規レイヤーを作りクリッピングをし、フィルターツールの水彩境界を使って線画をくっきりとさせます。

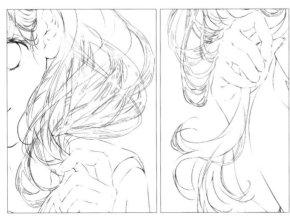

水彩境界を使うと、線を描かなくても、自動的にペン入れがされた状態になります。

95

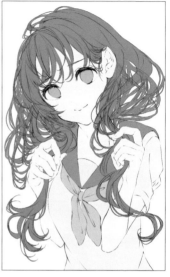

パーツごとに下塗りをしていきます。
手間・中間・奥と３つに分けていた髪の毛レイヤーは１つにまとめます。わかりやすいようにそれぞれの髪の毛は色を変えていましたが、ツールの線画色変更機能を使い、髪の毛の色を統一させます。

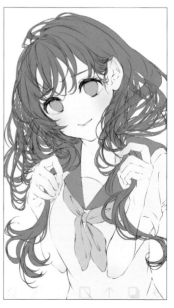

肌を塗ります。肌の下塗りをしたレイヤーの上にもう１枚レイヤーを作り、クリッピングをしてエアブラシで肌に赤みを足していきます。
赤みを足す部位は、目のキワ、頰、唇、指先、肘などです。エアブラシでふんわりと色をつけることで、自然で血色の良い女の子にできます。

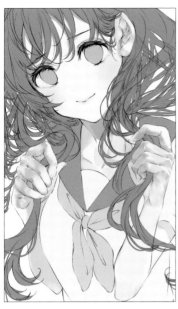

さらにレイヤーを重ね、クリッピングをしたあと、肌の質感を意識しながら陰影をつけていきます。
カゲに使うブラシは2種類で、カゲがはっきりするところはGペンハード、逆に柔らかさを出したいところはフェードペンです。指先ツールを使って、骨の出っぱりや肌のリアルな質感を調整します。

髪の毛レイヤーの上にクリッピングをし、顔にかかる髪を肌色のエアブラシで塗ります。こうすることで顔回りが明るく見え、透明感が出ます。

4 髪を塗る②

髪の毛のカゲやツヤをつけていきます。第一段階はGペンハードで、1本1本細い線で髪の質感を出していきます。このときはなるべく線がぶれないように、髪の流れに沿って線を引きます。

97

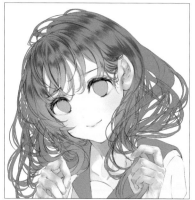

第二段階は、さっきの色より暗めの濃い色で上から重ねていきます。よりはっきりと、あでやかな印象になります。

薄く塗る作業と濃く塗る作業をひたすらくり返し、なじませます。

	普通
17:眉毛線画 ◉	100% 普通
16:線画 ◉	100% 普通
15 ◉	100% 普通
14 ◉	100% 普通
13 ◉	100% 普通
12 ◉	100% 普通
11 ◉	100% 普通
10	

新しいレイヤーでクリッピングをし、一番明るい色でハイライトを描きます。

目を塗っていきます。目のベースは下塗りの時点で塗っておきます。

目の中に瞳孔を描きます。

瞳孔を中心として、円を描くように線を引きます。髪の毛と同じ要領で線を1本1本描写します。

新規通常レイヤーを作り、濃い色でさらに描き込みます。目のハイライトをのちに入れるのですが、そうなると一気に明るくなるため、ここでは濃い色で線を描いておくのがポイントです。

第4章

白目を加えた目の上部分
に目のカゲを塗ります。
乗算レイヤーにして薄い
紫で塗っています。

そのカゲの上に肌色をさ
らに重ねます。これでカ
ゲのきつさが和らぎ、透
明感が出ます。

Point！

目の光や色は自由！　キラキラした目を描こう

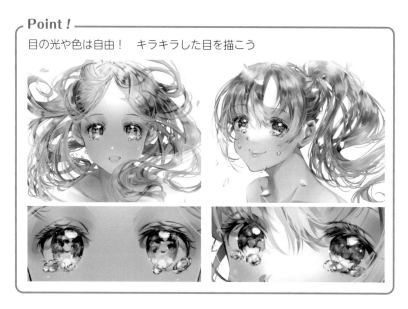

6 服を塗る

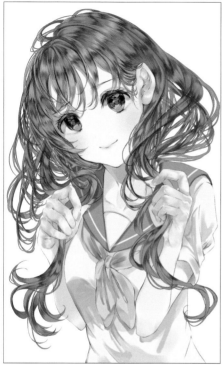

上から光が当たっているのを意識して
それぞれの下塗りパーツに乗算レイヤ
ーを重ねて、カゲや光をつけていき
ます。服は柔らかい素材なのでフェー
ドペンを使用し、ふんわりとした雰囲
気になるようにシワを描いていきます。

ひと通り全部カゲを塗り終
わったら、1番上のレイヤー
で「全結合を追加」機能を使用
します。

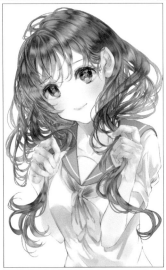

ここからは完成度を上げるための調整作業です。
レイヤーの全結合をした上から、新しくレイヤーを
作り、オーバーレイモードにします。
スポイトで各部位の色を抽出し、その抽出した色よ
りも彩度を少し上げた色をエアブラシでふんわりの
せていきます。これでイラストに鮮やかさがプラス
されます。

肌に水色を入れたりして透明感を出します。

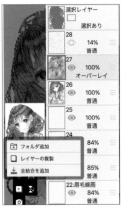

全結合をしたレイヤーを不透
明度選択します。

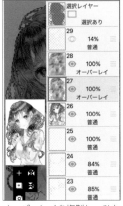

オーバーレイを複製し、ひと
つを下のレイヤーに結合させ
ます。

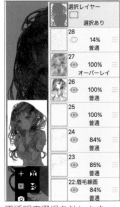

不透明度選択を外します。

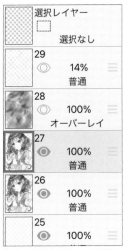

	選択レイヤー
	選択なし
29	◎ 14% 普通 ≡
28	◎ 100% オーバーレイ ≡
27	◉ 100% 普通 ≡
26	◉ 100% 普通 ≡
25	◉ 100%

結合させたレイヤーを複製します。

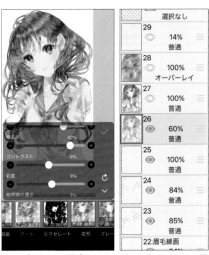

	選択なし
29	◎ 14% 普通 ≡
28	◎ 100% オーバーレイ ≡
27	◉ 100% 普通 ≡
26	◉ 60% 普通 ≡
25	◉ 100% 普通 ≡
24	◉ 84% 普通 ≡
23	◉ 85% 普通 ≡
22:眉毛線画	

オーバーレイで結合したレイヤーでフィルター機能のアニメ超風景を使用し、色を調整していきます。さらにそのレイヤーの不透明度を60%に下げます。

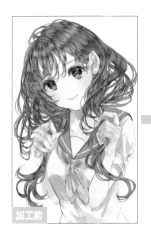

加工前

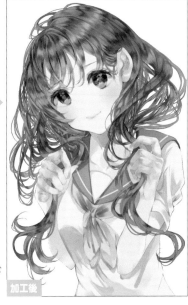

加工後

これでさらにイラストの彩度が上がった状態となります。

第 **4** 章

		選択レイヤー
		□ 選択なし
	29	14% 普通
	28	30% 乗算
	27	100% オーバーレイ
	26	60% 普通
	25	100% 普通
	24	84% 普通
	23	100% 普通

このままだと明るすぎるので、先ほどのレイヤーを乗算の線画色変更機能で暗くさせます。暗すぎるときは、レイヤーの不透明度を下げて調節します。

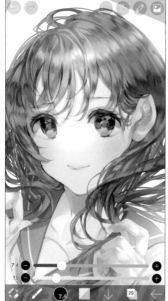

加算発光レイヤーで髪の毛のツヤを出していきます。このとき、手を動かすのではなく指の先だけを細かく動かすのがポイントです。

オーバーレイで目の色を明るくします。
このとき、血色感を出すために頬と唇
に赤みを足します。加算発光レイヤー
で光が当たる部分と、頬・瞼の中心・
鼻・唇・爪にそれぞれハイライトを入
れます。

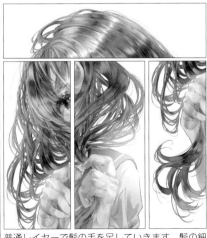

普通レイヤーで髪の毛を足していきます。髪の細
さを出すために線を妥協しないのがポイントです。

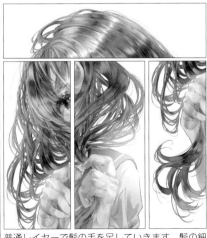

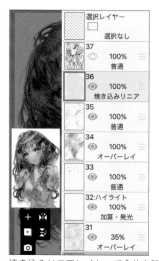

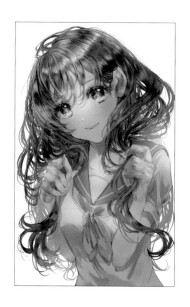

焼き込みリニアレイヤーで全体を暗くしたあと、光が当たる部分をエアブラシで消して調整します。上から加算発光レイヤーで明るい色で光を描きます。

8 涙を描く

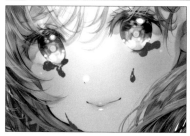

普通レイヤーの暗い色で涙の形を描きます。このとき使っているペンはGペン(にじみ)ブラシです。

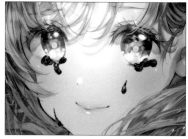

さっき使った色よりも濃い色で涙を縁取ります。立体感を意識するのがポイントです。

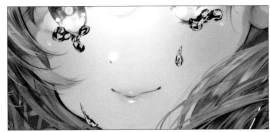

同じレイヤーで涙の
光が当たる部分に明
るい色をのせていき
ます。

消しゴムのGペン
(にじみ)ブラシで涙
の縁を残すように中
心部分を消していき
ます。

光が当たる高い部分
に加算発光レイヤー
で光を入れていきま
す。

オーバーレイでレイ
ヤーを重ねてなじま
せます。

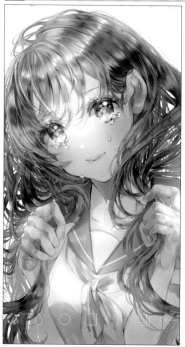

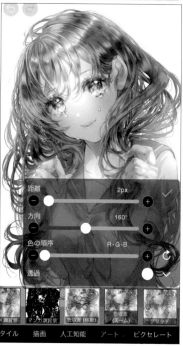

1番下の普通レイヤーをぼかして調整します。

イラストを保存したあと、色収差をして完成です。

スマホに指で描くときのコツ

・指の腹ではなく、指先の横で描くこと。

・気に入る線が描けるまで何度も描きなおすこと。

・手に汗をかくとストロークがしにくいので、パウダーなどを使って指と画面を滑りやすくさせること。

・同じ体勢だと体が痛くなるので、適度に体を動かすこと。

・なるべく拡大をして描くこと。

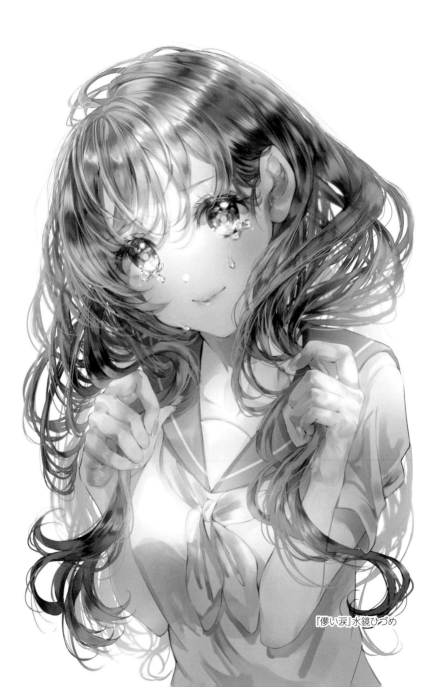

『儚い涙』水鏡ひづめ

背景のあるイラストを描く

イラストレーター：べんけのーび　使用ソフト：アイビスペイント
使用端末：iPhoneSE　作成時間：約19時間

1 ラフを描く

　今回のイラストは背景と人物を描くということで、『壮大な空中都市の中で暮らす人々の日常風景』というコンセプトで制作しました。

　イラストを効率的に描くためにまずはラフ画からですが、私の場合、ラフ画はスマホに直接描くのではなく、A4サイズの紙に鉛筆で描き、それを写真で取り込んだうえで線画抽出をして、それを下描きにして塗っていくという方法をとっています。

　また、その後の工程を迷わずスムーズに行うためにラフ画はなるべく細かく描いておきます。

　ペン入れをするイラストの場合も、線画抽出した線をトレースするようにペンを入れていけばいいので、スマホでラフ〜下描きを描くのが難しいという方はこの方法でもいいかもしれません。

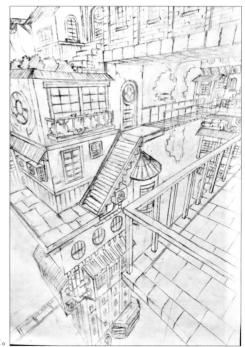

> **Point！**
> スマホだと細かい下描きが難しいという人はアナログで描くのもアリ！

ラフを写真に撮りました。

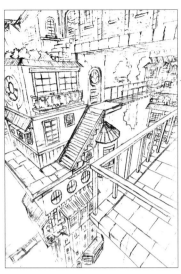

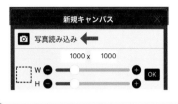

線画抽出したデータです。
これをそのまま下描きと
して使用します。

2 下塗り前の準備

　今回のイラストはかなり
幾何学的な立体物を描くの
で三点透視図法を用いま
す。

　集中線定規を使って消失
点の配置を決めます。ラフ
画の線との多少のずれは気
にせずに、この集中線定規
に沿って建物などを描いて
いきます。

ラフ画のままだと角度がずれたり
バランスが合わないときもあるの
でここで調整しておきます。

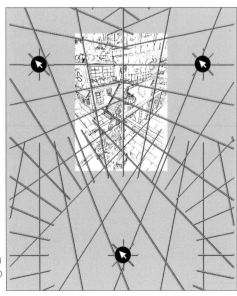

イラストを制作する上では、常に完成図や全体像を意識することが大切です。スマホなど小さなデバイスで作成する場合は特に気をつけます。

まずはイラストの完成図を意識するために、建物の概形と陰影のみ描きます。これだけでも、かなり全体像がイメージしやすくなったと思います。

左上の方に光源があるとして、どうカゲが映るかを決めておいて、あとで迷わないようにしておきます。

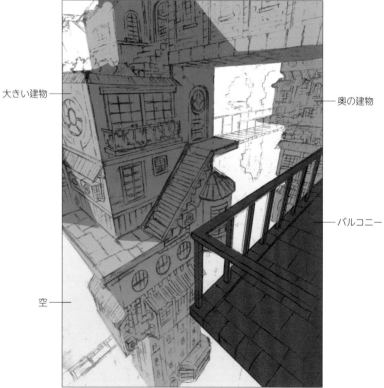

大きい建物

奥の建物

バルコニー

空

手前から、バルコニー・大きい建物・奥の建物・空の青いグラデーション、というふうにレイヤーを分けています。大きい建物の上にクリッピングで日の当たった明るい部分と青のグラデーションをのせていますね。

この段階ではペン（ソフト）で塗り、エアブラシ（標準）でグラデーションをかけています。

右上にある渡り廊下の部分から描いていきます。
建物を描く際の手順を順を追って説明していきます。

色の違う部分ごとに分けて描き、それぞれレイヤーを別にして保存します。フォルダーを作ってレイヤーをまとめておくといいでしょう。

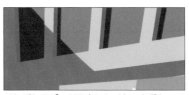

それぞれのパーツの上にレイヤーを重ね、クリッピングをした状態で日の当たる部分をつけ足します。

Point !

レンガ部分のレイヤー分けについて

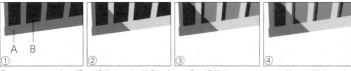

① A. クリーム色の石の部分と、B. 茶色いレンガの部分を、レイヤーを分けて描きます。
② A の上に別レイヤーを作りクリッピングして日の当たる部分を描きます。
③ B も同様です。
④ A の下に別レイヤーを作って石のカゲ部分を足します。
※画像は実際のメイキングイラストでなく、再現したものです。

カゲと日の当たる部分の境界に少し明るいぼかしを加えます。また、石のつなぎ目や割れ目も描き足していきます。

レンガの模様を描きます。エッジ部分の表現も足していきます。

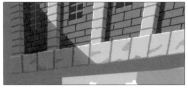

窓を描きます。これで大体、建物のイメージは完成です。

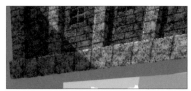

仕上げは石造りの質感を表現するためにフォルダーの上から素材をクリッピングします。今回は素材パターン(モノクロ)にある黒御影石_CSを使用しました。

クリッピングした素材の不透明度を調整します。そのまま使うと浮いてしまうので、なじむくらいまで不透明度を下げます。

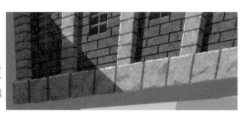

Point !

素材を使わない場合は壁やレンガに傷や割れ目、染みなどのノイズを加えてなるべくのっぺりさせないことが重要です。

直線だけで描くと立体感がなく、のっぺりしてしまいます。

傷

境目の隙間　　レンガ自体の立体感

レンガ1つだけ見ると、意外と角は削れてやや丸みを帯びています。

くり返しの配列パターンのある部分の描き方を解説します。このイラストの場合はレンガの壁の部分です。

対称定規のうちの配列定規を使用します。イラスト内の立体感に合わせるために、集中線定規の交点に定規の角を合わせます。

その定規を辺の部分を移動させて描きたい対象物に合わせ固定します。
分割数を調整して模様を描きます。

アイビスペイントにはさまざまな種類の対称定規がそろっています。うまく使えば効率的に正確なイラストを描くことができますので、是非活用してみてください。

このイラストでも、ほかにもいろいろな部分で使っています。

第 **4** 章

楕円を指で描くのは至難の業なので、楕円定規を使います。建物などの無機物はがんばって手で描こうとしなくても、使える機能はどんどん使っていくほうがいいと思います。楕円の軸の向きを立体物に合わせて考えていきます。

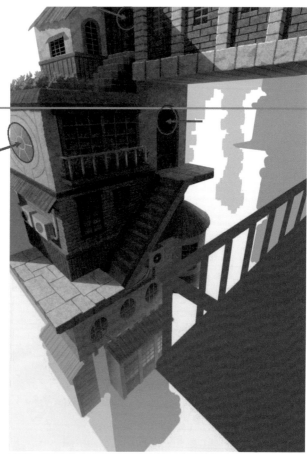

水平線の位置を気にしながら、消失点の方向に楕円の短軸を合わせると、立体物の壁に違和感なく張りついてるように見えると思います。

116

　背景の遠近感や空気感を表現するために、遠くにあるものは明るくかつコントラストを低めに描いていきます。

　今回はバックが空なので青味がかった色合いで描きます。

　建物だけ描いてから新規レイヤーをクリッピングして上からエアブラシで加工するのもありだと思います。

基本的には建物のかたまりごとに基本的
な手順（建物を描く①）に沿って描いてい
きます。
下のマンション的な灰色の建物ではここ
でも配列定規を使って窓などを規則的に
描いていますね。

フォルダ
⊙ 100% ≡
普通

7
⊙ 100% ≡
普通

6
⊙ 100% ≡
普通

5
⊙ 100% ≡
普通

4
⊙ 100% ≡
普通

レイヤーをすべて結合してしまうと、最後の仕上げのときに直しづらくなってしまいます。
ですので、このイラストでは階層ごとにレイヤーを分け、フォルダーにまとめて扱っています。

8 建物を描く⑤

　そのほかの建物部分も塗っていきますが、基本的な描き方は同じです。バルコニーについては大きく柵部分、床部分、縁石部分とレイヤーを分けています。柵を描くときにはここでも配列定規を使いました。遠近感を出すために、奥に行くにしたがってうっすら青いグラデーションをかけました。

9 雲を描く

奥に広がる雲を描きます。
雲 (わた) ブラシツールを選択して、入り抜きの太さや不透明度を調節して雲の形を光源の方向を意識しながら描いていきます。

青色の下地に光源の方向を意識して、日の当たった部分を白で描き足していきます。

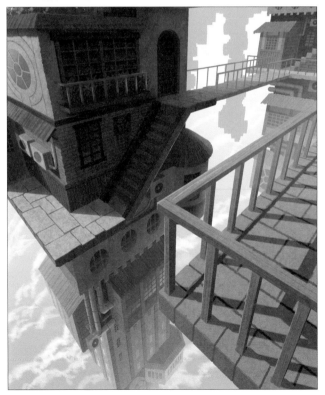

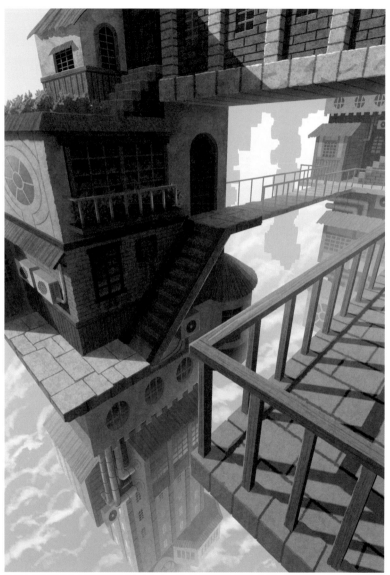

ここまででであらかた背景が完成しました。仕上げの段階で直したりつけ加えたりする可能性があるので、レイヤーはまだ結合せず、かたまりごとに残した状態にしておきます。

　背景がほぼ完成したら、人物を描き込みます。人物も背景と同じように、まずは下描きを紙に描いて、写真で取り込みます。

　撮った写真の線画抽出をして絵の中での人物の配置を決めます。

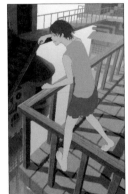
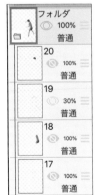
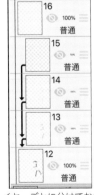

肌、服、髪、輪郭線を大まかな色でベタ塗りして、レイヤーごとに分けておきます。
少しわかりづらいかもしれませんが、19 は下描き線画、17 は顔や手足の輪郭線、16 は目や口の色です。12 が肌色部分のレイヤーなのですが、その上にクリッピングで日の当たる部分、境界部分のぼかし、黒御影石の素材、をのせています。

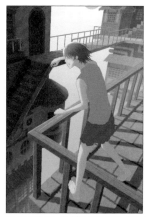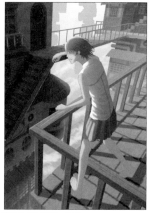

光源を意識しながら日に照らされた部分を描き足します。
パーツごとにレイヤーを分けておくことで、クリッピングによって描き
足しやすくなります。

柵が手前から奥に回り込
むように設置されている
ので、人物が被っている
部分を消去します。

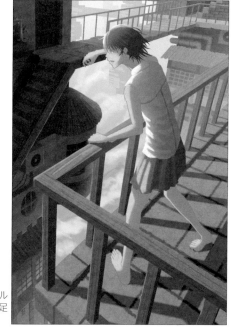

コントラストを調整し、バル
コニーに落ちるカゲを描き足
したら人物は完成です。

11 光を足す

空気感を出すためにエアブラシで左上方向に光を足します。

12 奥の建物を描く

奥の構造物を描きます。細かく描く必要はありませんが、奥行きが伝わるようにシルエットをしっかりと描きます。

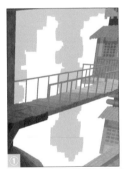
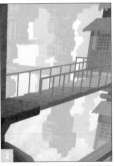

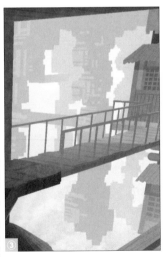

①描き方としては、まずシルエットだけで複雑な構造物を表現します。ペンはデジタルペンを使っていてカスタマイズで形状のブラシパターンをドットにしています。角張った構造物を描くのに便利です。
②シルエットのレイヤーを複製し、平行移動させて色を薄くすることで、さらにもっと奥の構造物を表現します。
③手前のシルエットに少し明るい色でまたデジタルペンを使って模様を描き足し、それっぽく複雑に入り組んだ街感を表現します。黒御影石の素材を上からかぶせてほかの部分と比べて浮かないようになじませます。

13 仕上げ

　人物が仕上がり、背景となじませたら、色合いやコントラストを調整して完成です。

全体的な空気感になじませるために雲や奥の構造物の色相をやや緑に寄せて、建物のコントラストを少し下げました。あと左上からの光のエフェクトを濃くしています。

イラストのポイント

- ラフを細かく描いておくことで、そのあとの作業を迷わず進めることができるようになる。
- レイヤーを細かく分けて、フォルダーを使って整理しながら描くと作業しやすくなる。
- 定規、分割定規などを利用して幾何学的な構造物を描く。
- こまめに拡大と縮小をくり返して全体像を確認しながら描く。
- 光の方向や空気感を意識することで、構造物の立体感を引き出す。
- 完成したあとは、少し時間をおいてから違和感がないか見返す。

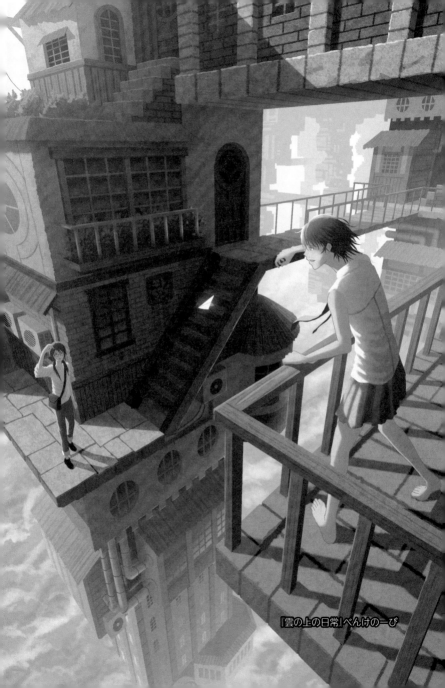

『雲の上の日常』べんけのーび

スマホに指で描くときのコツ

・指で塗るときのコツは、なるべく短いストロークで細かく刻むようにして輪郭から塗ること。

・指の動かしやすい方向は大体決まっているので、適宜描きやすいように絵の向きを変える。

・はっきり言って、指の動きを狭いスマホの中で完璧にコントロールするのは不可能。そのためフリーハンドに頼らず、定規やクリッピングで正確さを高めたり、移動変形などを利用しながら後から形を修正したりなど、さまざまな機能を使って臨機応変に描き方を考えること。

▶ **スマホで描いた作品例**

光の輝きや反射の仕方を工夫することで、都市の夜景や雨で反射した地面などを表現しました。

生き物の毛並みや自然の草木などの柔らかい質感もGペンやエアブラシなどの基本的な機能で表現できます。

126

マンガの制作について

アイビスペイント、クリップスタジオペイント、メディバンペイントなどの
アプリは、マンガを描くための機能も備わっています。マンガを描く場合、テ
ンプレートを使ってコマなどを描くこともあると思うので、簡単にテンプレー
トの線について紹介します。ただし、このテンプレートは基本的に同人誌を
作ったりするための線で、WEB 上で公開するだけなら、特に気にせず描いて
いいでしょう。

WEBTOON と言われるような縦長マンガを描く場合、クリップスタジオペ
イントには最初から縦長マンガ用のテンプレートがついています。

ただし、縦サイズが非常に長いので、Twitter などにアップする場合には、
適度に分割してアップすることをおすすめします。

拡大しないと読めなかったり、サムネイルでは全然見えないこともあります。

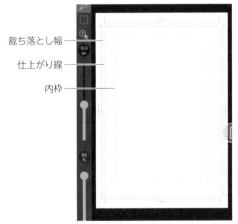

裁ち落とし幅
仕上がり線
内枠

一番中の枠は内枠と言って、大事なセリフ
などはこの枠内に描いたりします。外側の
二重枠は仕上がり線と、断ち切りで少しず
れたりするための裁ち落とし幅になります。
一番外の枠まで描いておくのが普通ですが、
実際の断ち切りは仕上がり線になります。

縦長マンガ用のテンプレー
トは、WEB 上でそのまま
アップすると読むときに拡
大しないといけないので、
読みやすいように分割した
ほうがいいでしょう。

小物や生き物のいるイラストを描く

イラストレーター：こんぺいとう＊＊　使用ソフト：アイビスペイント
使用端末：iPad Pro(10.5inch)　作成時間：約6時間

　使用端末は iPad になりますが、アプリは同じアイビスペイントです。スマホでは難しい細かい描写などが、タブレットならできるようになります。
　発展編として、1 枚のイラストを完成までしっかり解説していきます。

1 ラフを描く

まずはざっくりとしたラフを描きます。

小物など細かいところも描いていきます。

　サイズは B6 サイズ、350dpi で作成しています。ペンの太さなとはそのサイズを前提にして紹介します。まずは、イラストのイメージをラフに起こしていきます。ラフができたら、レイヤーを重ねて、細かく描き込んで下描きを作ります。
　ここで、すぐにペン入れに入るのではなく、一度完成イメージの色を作っておきます。この過程をしておくと、塗るときに何色を使おう、と困ることはありません。

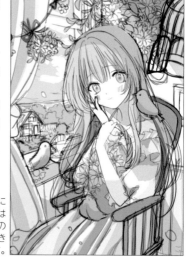

たくさんの色を使うとイラストにまとまりがなくなるので、今回は青をメインに、パステル調の女の子にします。花や外の風景もできるだけ同じような色でまとめます。

顔の細部から線画を描きます。

髪の毛の束は細かく描き足し、最後にいらない線を消します。

配色が決まったら、ペン入れをしていきます。配色のレイヤーは一旦非表示にしておきます。

ペン入れの色は真っ黒ではなく、濃い茶色、太さはGペン（ハード）1.2px です。

Point !

定規ツールを活用！

無機物は、フリーハンドで描こうとしても、どうしても歪んでしまうので、遠慮なく定規ツールを使います。定規ツールを使えば、線も均一に描けるので、本格的な背景らしさを出せます。

窓の線は定規を使って描きます。人物と被る線は描き終えてから消します。

第4章

129

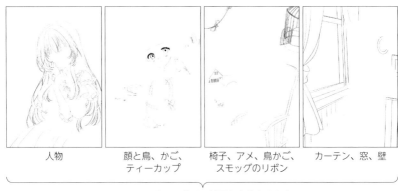

| 人物 | 顔と鳥、かご、
ティーカップ | 椅子、アメ、鳥かご、
スモッグのリボン | カーテン、窓、壁 |

4つのレイヤーに分けて線画を完成させます。

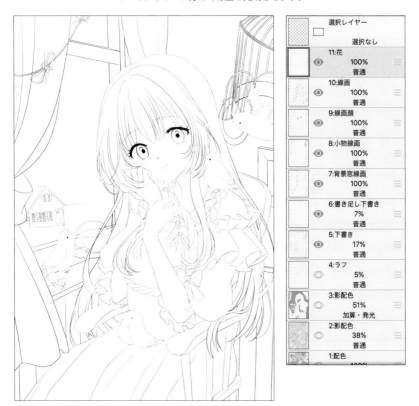

選択レイヤー
□
選択なし

11:花
100%
普通

10:線画
100%
普通

9:線画顔
100%
普通

8:小物線画
100%
普通

7:背景窓線画
100%
普通

6:書き足し下書き
7%
普通

5:下書き
17%
普通

4:ラフ
5%
普通

3:影配色
51%
加算・発光

2:影配色
38%
普通

1:配色
100%

3 花を描く

最初に輪郭の小物や背景を描くことで、色のイメージがまとまるので、人物より先に完成させます。

線画レイヤーなどの一番上にレイヤーを作り、花を描いていきます。

種類：Gペン（ハード）
サイズ：6.9px
不透明度：88%

下地を描きます。後ろ側の花は
暗い色で差別化します。

花の真ん中部分のカゲを描き
ます。

中心にあるおしべを黄土色
で描いたあと、明るい黄色
で明暗をつけます。

花びらのカゲをつけます。

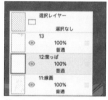

花のレイヤーの上に葉の
レイヤーを作ります。

葉の下地をGペン（ハード）
6.4pxで描きます。

下地より明るい色で明暗を
つけます。不透明度60%
で描くとなじみます。バラ
ンスを見ながら光の当たる
部分にだけ加筆します。

葉っぱの下地より暗い色は、
葉っぱの明るさが引き立つ
ように、はっきりと加筆し
ます。

　同様に、イラスト左上部分のバラを描いていきます。塗り方は基本的に花と同じです。

水色のバラと葉っぱの下地を描きます。

種類：Gペン（ハード）
サイズ・3.0px
不透明度：93％

バラの花びらと葉っぱを下地より明るい色でペンを細くして描きます。

花びらの下部をぼかします。少しぼかすことで柔らかい質感に見えます。また、先端のバラの中身に奥行が出るよう、下地より濃い色で塗ります。

スモッグの小花と花、葉っぱの下地をGペン（ハード）3.0px、不透明度93％で描きます。

花と小花の中心に、下地より濃い水色でカゲを入れます。また、中心におしべを描き加えます。

投げ輪ツールでスモッグを選択して大きさを調整します。今回は全体の小物のバランスを考え、拡大しました。

5 木を描く

窓背景のレイヤーを作り、線画にない木を描いていきます。木を描くときは
ブラシを使っています。

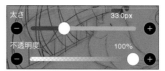

葉群れ 2 ブラシを選択し、太さは
33.0px に調整します。

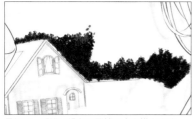

最初に一番濃い緑色で下地の木を描きます。

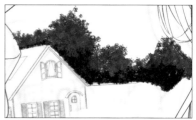

下地より明るい緑色で木の明るさを描き足し
ます。

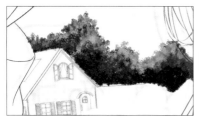

さらに明るい緑色を足します。

後ろの木は手前よりくすんだの緑色を
選ぶことで、遠近感が出ます。

133

6 海を描く

窓背景のレイヤーの下に海のレイヤーを作ります。

Gペン下地より明るい水色で海の水面の光を描きます。サッと流れるように線を引くと、光をリアルに表現できます。

海の下地を定規とGペン(ハード)を使って若干斜めに描きます。斜めにすることで奥行きが出る気がします。

さらに明るい水色を重ねます。その後、窓背景に海のレイヤーを結合します。

7 庭を描く

草むらのレイヤーとテーブルのレイヤーは別にして描きます。

ブラシの草(スゲ)を選択します。

草(スゲ)とGペン(ハード)で草むらを描いていきます。また、エアブラシ(台形60%)で草むらに明るさをつけます。

Gペン(ハード)0.9pxでクリーム色のテラスを描きます。濃い色でカゲをつけて、草むらとともに、窓背景レイヤーに結合します。

8 人物の下塗りをする

　女の子が持っている花も**3**と同様に描いたのち、一度小物と背景はストップして、ここから人物を塗っていきます。

花は少し垂れ気味に描くと、かわいい印象になります。

線画レイヤーたちの下に、上から鳥かご・家・壁、小物・本背景・背景の順番でレイヤーを作ります。下描きレイヤーは使わないため、一番下に置いておきます。背景を塗り残し防止のため、わかりやすい水色で塗りつぶしておくのがおすすめです。

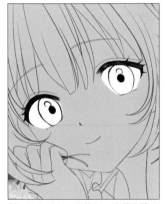

新しいレイヤーを作り、白目を塗ります。肌を先に塗ると白と肌色との差別がつきにくいので、先に白目を塗るのがよいでしょう。

肌、目、髪などのパーツをそれぞれのレイヤーに分けて、下地の色を塗っていきます。

第**4**章

135

　下塗りができたら、肌のカゲをつけていきます。私の場合は、乗算レイヤーでカゲをつけるのではなく、下塗りより濃いめの色を使って通常レイヤーでカゲをつけます。その代わり、カゲレイヤーの不透明度を下げて下塗りの色となじませるようにしています。

レイヤーを重ねて、肌のカゲをGペン（ハード）10.8px不透明度60％で塗ります。不透明度を下げることででで柔らかな肌に見えます。
濃いめのコーラルピンクで首から鎖骨周りを塗ります。

さらにもう一段階濃いカゲをつけます。このレイヤーも不透明度を65％に落としています。

鎖骨の下部を塗り、ぼかしツールでぼかします。

肌にうつる髪の毛のカゲをつけたあと、濃いコーラルピンクでフチを描くとカゲが強調されて、メリハリのあるイラストになります。

腕のカゲは首より薄い色にします。光が当たるところをぼかすことで、柔らかな腕を表現できます。

腕の一番深いカゲを塗ります。

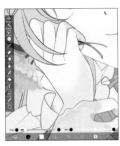

配色ラフを見ながら光が当たる場所を確認しつつ、手のカゲを塗り、ぼかして柔らかいカゲにします。

もう一段階濃いカゲをつけます。線と線の隙間など、くっきりと描き入れます。

肩にはエアブラシを使い、ピンク色でカゲを入れます。力を入れてしまうと肩が強調されるため、軽くブラシでタッチする程度です。

発光でツヤをつけることで丸みが表現され、リアルな印象になります。

発光で鼻筋、顔の左側にハイライトを入れて立体感を出します。頬は、ピンク色のエアブラシで軽く塗ったあと、濃いピンク色で斜線を描くと、可愛らしさが増します。

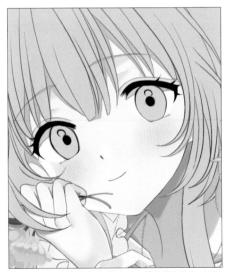

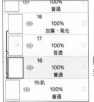

肌のレイヤーの上に新しいレイヤーを作り、肌レイヤーにクリッピングします。

まぶたと眉毛のカゲを描き入れます。これで肌の塗りは完成です。

137

　目はキャラクターの命です。そのため、気合いを入れて細かく塗っていきます。また、最後にホワイトでまつ毛を描き加えるのもおすすめで、ひと手間でぐっとかわいい目になります。

新しいレイヤーを作ります。一枚は目の周りを描くためのレイヤー、もう一枚は光を入れる発光レイヤーです。

瞳の縁を灰色でなぞり、強調します。

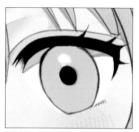

発光レイヤーで目のハイライトを入れます。薄い水色→白の順番に重ね塗りをすると滲んだような光になります。

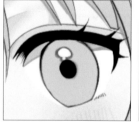

ハイライトにも暗めの水色で縁取りしておきます。

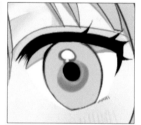

瞳孔の下に円を描きます。

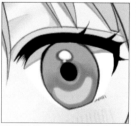

瞳の下部に三日月型を残しつつ、グラデーションをつけます。

三日月型を濃い水色で縁取って、その中に細かな線を入れてリアル感を出します。

発光レイヤーに戻り、Gペン（ハード・不透明度80%）で、水色で瞳の上部に半円を描きます。

両端をぼかしたあと、半円部分を投げ輪ツールで囲い、色調整で青寄りの水色に変更します。

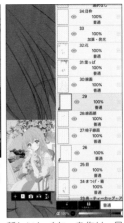

新しいレイヤーを作り、目の線画があるレイヤーにクリッピングします。

瞳の線画を少し濃い水色で描き直し、上まぶたにもラインを入れます。発光レイヤーで瞳孔やその周りに小さなハイライトを入れます。

まつ毛の光を水色でばしばし描き加えます。

発光レイヤーに戻ります。エアブラシでまつ毛の線画を淡いオレンジ色にします。目も下から淡い光を入れて、完成です。

種類：Gペン（ハード）
サイズ：15.0px
不透明度：80％

カゲの縁にさらに濃い色を入れます。
このひと手間でパキッとしたメリハリのある髪の毛にできます。

毛の流れに沿ってカゲを描き入れます。

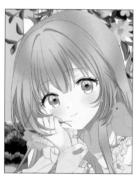

カゲのレイヤーの下に新しいレイヤーを作り、クリッピングします。エアブラシで輪っかを描くようにカゲを入れてから、さらに濃いカゲをつけていきます。

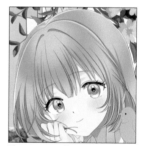

淡いクリーム色で頭頂部などにハイライトを描きます。

輪っかの内側に明るい輪をもうひとつ作ります。髪のツヤです。

ツヤを消したり描き加えたりして、形を不規則に作っていきます。

Point !

髪は、人物の中でも目立つ部位なので、立体感を出したり、ツヤを出したりと、丁寧に塗っていきます。

のっぺり…

ツヤッ

前髪と同じように、ほかの部分の毛束にもツヤを追加。

明るい色を入れて、形を整えるのくり返しです。

頭頂部にさらにツヤを加えます。薄い黄色で入れます。

重ね塗りをしながら形を整えます。

投げ輪ツールで淡い黄色のツヤを囲い、水色に変えます。

レイヤーはこんな感じ。塗り重ねるたびにレイヤーを増やしています。

エアブラシ（台形60%）を使って、前髪や毛束の中心、髪の毛を囲うように強い光を入れます。
1本1本の髪を少し描き入れて完成です。

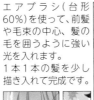

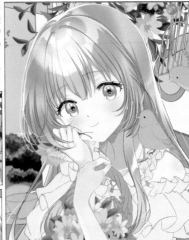

フリルの凹凸を意識しながら、光が当たる場所（凸部分）を白っぽい水色で塗っていきます。端をぼかすことで柔らかいカゲになります。

フリルの裏地部分など、濃いカゲを入れます。バケツツールで一気に塗ります。

カゲを細かくしていきます。こちらも縁が濃くなるように。

さらに濃いカゲをつけていきます。フリルの丸みを意識して、カゲも丸く入れます。

縁をぼかします。

袖やスカートなども同様に塗っていきます。

リボンも、1カゲ、2カゲ、2カゲに濃い縁、そしてハイライトと何層にも塗りを重ねています。

13 花かごを塗る

　人物があらかた塗り終わったので、家具や小物などの塗りに戻ります。小物が多いとそれぞれ塗っていくのは根気のいる作業ですが、丁寧に塗ることで完成したときのクオリティが変わってきますので、コツコツ塗っていきます。

まずはざっくりとしたカゲをつけていきます。持ち手は捻っているので、丸みを意識します。

細かい網目は、細かな線をたくさん描きます。根気のいる作業ですが手間をかけるとそれだけ完成度が上がります。

網目のくぼむ部分に縦線を引いてメリハリを出します。

かごのくぼむ部分を意識しながら、さらにカゲを入れていきます。

手が落とすカゲ、葉が落とすカゲなどを細かく描き入れます。

14 鳥を塗る

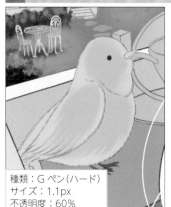

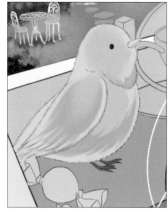

種類：Gペン（ハード）
サイズ：1.1px
不透明度：60％

鳥の形を囲うようにハイライトを入れ
ます。毛並みと鳥の丸みを意識します。

カゲを毛並みに沿って描きます。翼の
中心を薄くぼかします。

15 飴を塗る

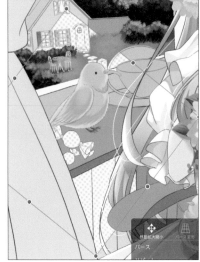

飴はギンガムチェックの素材を使います。

色調整で素材の色を暗めに変更し
ます。

ハイライトを入れます。丸い飴が
わかるように、ハイライトもカゲ
も丸く入れるのがポイントです。

第4章

145

今回はガラスのティーカップなので、薄い色に不透明度を下げたGペンでのせていきます。四角い光を当てるのがリアル感を出すポイントです。

オレンジ色を加えて、ぼかしツールで少しだけぼかします。

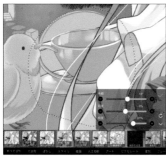

輪投げツールでティーカップを囲い、色調整の色相・彩度・明度で灰色に調整します。色が想像つかないときは、塗ったあとから色を調整しても大丈夫です。

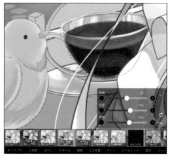

紅茶部分を不透明度を下げたGペン（ハード）で塗ります。色調整の色相・彩度・明度で紅茶色に調整します。

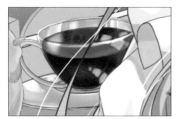

発光レイヤーを作り、Gペン（ハード）を使って、オレンジ色で窓の反射を表す四角いハイライトを入れます。

表面のハイライトを入れ、ぼかして完成です。

146

17 カーテンを塗る

種類：
G ペン(ハード)
サイズ：5.0px
不透明度：60%

淡いクリーム色を入れていきます。

光を強調するためにパキッとしたカゲを描きます。一番強いカゲを細かく描くことで立体感が生まれます。

18 写真立てを塗る

エアブラシ(台形60%)を使って、濃い水色でカゲをつけます。

水色できわに線を入れ、カゲをつけるところははっきりすると立体感が出ます。

写真も描きます！ こういう細かいところまで描くことで完成度に差が出る気がします。

光を入れて質感を出します。

19 鏡を塗る

鏡の枠にカゲをつけて立体感を出します。ハイライトも入れました。

種類：Gペン（ハード）
サイズ：20px
不透明度：71%

枠の模様を描きます。
今回はバラにしました。

淡い黄色でツヤを描くとバラの花びらに立体感が出せます。

薄い水色で光を入れます。

青い鳥が鏡に映る姿を描き、軽くぼかします。これで鏡らしさがアップしました。

20 鳥かごを塗る

Gペン（ハード）を使い、クリーム色でカゲをつけていきます。

さらに濃いカゲを入れます。ハイライトはきわの線を入れると立体感が出ます。

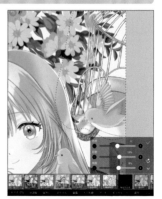
色調整の色彩・彩度・明度で色を調整します。

21 椅子を塗る

木目に合わせて、
一枚ずつ素材を
貼っていきます。

Gペン(ハード)を使い、濃い茶色
で手すりや背もたれを塗ります。

塗った場所をぼかしていきます。た
だ、強いカゲはぼかしません。

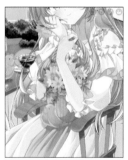

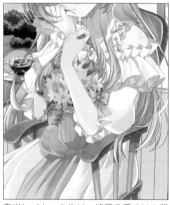

貼り終わったレイヤーを結合
し、モードをソフトライトに
変更します。

色調整の色彩・彩
度・明度で色を調整
します。

発光レイヤーを作り、椅子の手すりや背
もたれの角にツヤをつけます。

第4章

Point !

素材やテクスチャを貼るときは
ベタッと貼るのではなく、変形
したりパーツごとに貼り替えた
りして、リアル感を出しましょ
う。

屋根にカゲをつけます。屋根のきわを塗り残すことで立体感が生まれます。

ぼかしツールでぼかしていきます。

家の壁を発光レイヤーで明るくします。柔らかい太陽光が当たっているイメージです。

塀は茶色のカゲを塗り、ぼかしツールでぼかします。

新しいレイヤーを作り、クリッピングしてからレンガの素材をのせます。

ブレンドモードのソフトライトを選択します。

発光レイヤーで薄く茶色の光を入れます。

庭の門を描きます。木目をGペン（ハード）を使って描いていきます。

一番強いカゲを不透明度を下げて、上から重ねて塗ります。

エアブラシ（台形 60%）を使って、下の部分を淡い水色でグラデーションにします。

雲のブラシを使い、まばらに雲を描きます。このとき、消しゴムのエアブラシ（台形 60%）で削りながら描くと、自然な雲ができます。

白色で上から雲を重ね塗りをすることで、雲にカゲができます。

バランスを調整する際は投げ輪を使用します。

Point !

空の色もほかの色に合わせて、やや緑がかった水色にしています。

完成です。

24 加工する

顔の線画の色を変えます。新しいレイヤーを顔の線画があるレイヤーの上に作り、クリッピングします。

エアブラシ（台形60％）を使って、肌部分の線に軽く、暗い赤を入れます。

一番上に新しいレイヤーを作って、オレンジ色で塗りつぶします。

不透明度を17％まで下げると、全体的に淡いオレンジのイラストにできます。

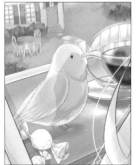
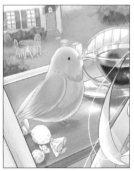

一番上に発光レイヤーを作り、鳥の外面を覆うように光を入れます。

ぼかして形を整えます。

窓側の花束にも立体感やカゲが強調されるよう、光を入れます。

鍵の明暗をつけます。
白い光、茶色いカゲ
色と、くっきり差を
出すことで金属感を
出せます。

キラ4-加算・発光と
ほわ円（内）を使って、
周りをキラキラな印象
にします。

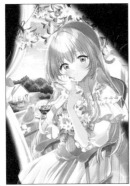

カーテンのカゲを強調させる
ため、エアブラシ（台形60%）
で黒に近い色をカーテンの周
りに塗ります。

	63	
◉		39%
	加算・発光	
◉	62	
		31%
	加算・発光	
◉	61	
		12%
	焼き込みカラー	
◉	60	
		13%
	焼き込みカラー	
	59:目枠	

ブレンドモードの焼き込みカラー
を選択し、カーテンのカゲの不透
明度を12%まで下げます。

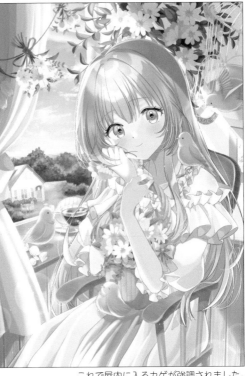

これで屋内に入るカゲが強調されました。

	選択レイヤー	
	選択なし	
64		
◉	100%	
	普通	
63		
◉	39%	
	加算・発光	
62		
	24%	

最後の加工のために、一度保存します。保存するとレイヤーは統合されて1枚のレイヤーになるので、それを再びレイヤーが分かれている作業中のレイヤーの一番上にコピー&ペーストします。

重ねたレイヤーの色調整の明るさとコントラストを選択します。明るさを−70%、コントラストを65%にするとこのような暗いイメージになります。

ぼかしツールのガウスぼかしを選択します。半径50pxにすると、ぼやっとした状態になります。このレイヤーをブレンドモードのリニアライトに変更し、不透明度を11%まで下げます。

最後に鳥の嘴部分に花を描き加えます。

目のハイライトも微調整を加えて完成です。

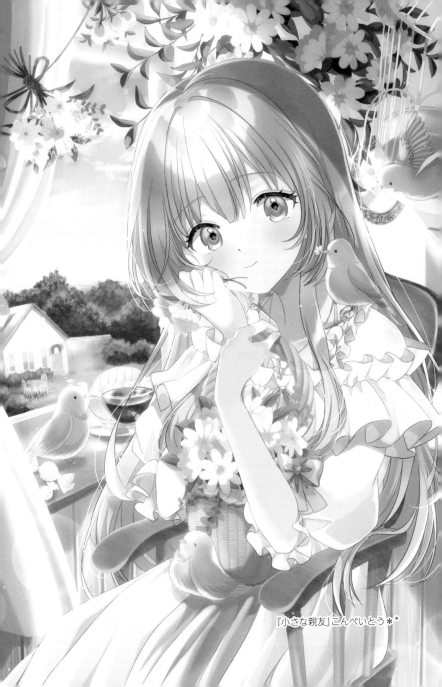

「小さな親友」こんぺいとう＊＊

スマホからステップアップするには？

スマホでのお絵描きから、もう少し本格的にイラストを描きたいという人は、次にどういう端末を準備すればいいか？　それぞれの特徴、メリットとデメリットをお知らせします。

1. iPad などのタブレット + Apple Pencil

スマホを大きくしたバージョンということで、一番スマホから似たような感覚で使えるのがこちらです。mini から Pro まで、サイズや価格も幅がありますが、mini の安いもので大体 5 万円程度（2021 年 10 月末現在）から購入することができます。

タッチペンは Apple Pencil を用意しますが、こちらが大体 1 万円前後です。ただし、感度はとても良く、鉛筆のようになめらかに描くことができます。

iPad のメリットは、持ち運びができるということと、自由な姿勢で描けるということです。スマホとほとんど同じ感覚で、スマホよりははるかに緻密なイラストを描くことができます。

デメリットは、マンガなど、多くのデータを作るときに不便かもしれません。また、データを別の端末にアップロードするときなど、データのやりとりは煩雑です。

ただし、イラストを描いて、SNS にアップするだけでしたら、十分な機能を持っています。

2. PC +板タブレット（板タブ）

板タブレットというのは、板状で、そこにペンを走らせることで、モニター上でペンを動かせるペンタブレットになります。マウスの代わりに使えるペンという感じです。ただし、ペンタブはただの板なので、どこを描いているかなどは、常にモニターを見ていないとわからないようになっています。

メリットは液晶タブレットよりは安価な点です。数千円くらいから手に入ります。ペンタブ初心者で、いきなり液タブはハードルが高いという方におすすめです。

デメリットですが、アナログと違う描き味や描き方に慣れるのに時間がかかる点です。アナログでお絵描きをする場合、紙を見ながら描いていくと思いますが、板タブの場合は、手元は見る必要がなく、常にモニターを見ながら作業しないといけません。なので、

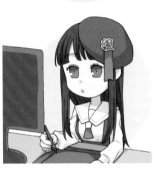

手元で描いている感覚が希薄で、細かい描写などをできるようになるまでに時間がかかると思います。

3. PC +液晶タブレット（液タブ）

液晶タブレットは、液晶モニターのペンタブレットで、液晶モニターに直接描き込むことができます。デジタルマンガを描くプロの漫画家やイラストレーターの多くがこの液晶タブレットを使用しています。

設定すれば、PC のモニターと、液タブのモニターに同じ作業画面を表示できるので、手元で描いて、大画面で確認する、という使い方もできます。

メリットは、アナログでお絵描きをするときとかなり似たような感覚で描ける点です。これは iPad も同じですが、それに加えて、iPad よりもさらに高解像度のイラストを描いたり、たくさんのデータ管理ができるようになります。マンガの制作にも一番向いています。

　デメリットは、板タブに比べて高価な点です。また、これは板タブ、液タブ共通ですが、同じ姿勢で作業し続けるため、肩凝りや腰痛に悩まされやすいことです。体に合うデスク、イス、適度な休憩など、作業環境を整えることも必要になってきます。

　2 と 3 の場合、PC はノートパソコンではなく、デスクトップパソコンをおすすめします。お絵描きはデータのサイズが大きいので、ノートパソコンでも描けなくはないですが、処理に時間がかかったり、すぐ熱を持ってしまったり、正しい色が出なかったりすることもあります。値段は上がりますが、パソコンでお絵描きをする！　と決めたら、ノートよりはデスクトップ、板タブよりは液タブをおすすめしたいと思います。

　板タブも最初のペンタブとして使ってみるのはアリですが、長く描いていきたいなら、液タブのほうが、繊細な描写や、自分が思う通りの線が引けたり、何より紙と同じような感覚で描けることが最大のメリットだと思います。

　もちろん、個人差や好みもありますので、液タブよりも板タブのほうが向いているという人もいます。あくまで参考程度に読んでいただければ幸いです。

　スマホのお絵描きももちろん楽しいですが、これらのツールでのお絵描きは、もっと世界が広がり、自分の絵の可能性を広げられると思うので、もし金銭的に余裕ができたら、是非チャレンジしてもらいたいと思います。

サコ
`Pixiv` https://www.pixiv.net/users/22190423
`Twitter` @35s_00

水鏡ひづめ
`Pixiv` https://www.pixiv.net/users/52296099
`Twitter` @pinapo_25

べんけのーび
`Pixiv` https://www.pixiv.net/users/25920509
`Twitter` @BenKenobi2187

こんぺいとう＊*
`HP` https://lemoongarden.wixsite.com/konpeito
`Twitter` @Konpeito1025

なごん
`Pixiv` https://www.pixiv.net/users/32350978
`Twitter` @nagon_jinroh

ふじ

弓柄

著者　（萌）表現探求サークル

男性向け・女性向け問わずマンガやアニメ、ゲームなどが大好きな人たちの集まり。日々、イラスト上達のための表現技法を模索中。代表作は『萌え　ロリータファッションの描き方』シリーズ、『女の子の服イラストポーズ集』、『軍服の描き方』シリーズなど。

スタッフ

編集	沖元友佳（ホビージャパン）
カバーデザイン	フネダスズ
本文デザイン・DTP	甲斐麻里恵

スマホで描く！　はじめてのデジ絵ガイドブック

2021 年 10 月 29 日　初版発行

著　者	（萌）表現探求サークル
発行人	松下大介
発行所	株式会社ホビージャパン
	〒 151-0053　東京都渋谷区代々木 2-15-8
	電話　03-5354-7403（編集）
	03-5304-9112（営業）
印刷所	大日本印刷株式会社

©Moe Hyogen Tankyu Circle/HOBBY JAPAN
Printed in Japan
ISBN978-4-7986-2591-1　C2371